The Campus History Series

UNIVERSITY OF NEBRASKA–LINCOLN

On the Front Cover: The Crib, located in the Student Union, was a popular hangout for students in 1949. Walls in the Crib were decorated with murals depicting campus scenes and activities. The Love Library cupola is visible in the mural to the left of the door. (University Libraries Archives and Special Collections Department, University of Nebraska.)

Cover Background: Twelfth and R Streets were a hub of activity at the start of classes in September 1946. Twelfth Street, famously dangerous for pedestrians, was closed to create a pedestrian mall in the mid-1960s. (University Libraries Archives and Special Collections Department, University of Nebraska.)

The Campus History Series

UNIVERSITY OF NEBRASKA–LINCOLN

KAY LOGAN-PETERS

FOREWORD BY RONNIE GREEN, CHANCELLOR

To Virginia

Kay Logan-Peters

ARCADIA
PUBLISHING

Copyright © 2017 by Kay Logan-Peters
ISBN 978-1-4671-2558-1

Published by Arcadia Publishing
Charleston, South Carolina

Printed in the United States of America

Library of Congress Control Number: 2016954856

For all general information, please contact Arcadia Publishing:
Telephone 843-853-2070
Fax 843-853-0044
E-mail sales@arcadiapublishing.com
For customer service and orders:
Toll-Free 1-888-313-2665

Visit us on the Internet at www.arcadiapublishing.com

Dedicated to Huskers everywhere, past, present, and future.

Contents

Foreword		6
Acknowledgments		7
Introduction		8
1.	Founding a Prairie University	11
2.	The Best in the West	25
3.	Meanwhile, at the Farm	39
4.	Pioneering Women	47
5.	Growth and Change	57
6.	Rituals, Rites, and Student Fun	71
7.	Dark Days	81
8.	Becoming a Research University	89
9.	Building a System	109

FOREWORD

It is my great honor to provide a glimpse into *University of Nebraska–Lincoln* by Kay Logan-Peters. Kay has proven to be a treasure for the University of Nebraska, enlightening us with her knowledge of the momentous and the trivial, the prominent and the obscure, the headlines and the footnotes, not only of our university's past but of the history of the Morrill Act, which changed the shape of our educational system in America and America itself.

The establishment of the University of Nebraska—and so many other public land-grant universities across the United States—represents the idealism that buoyed the beliefs of citizens and immigrants alike who faced plague, drought, hunger, and any number of harsh realities on a daily basis as they made their way in this new country. Places of higher learning were unprecedented in these parts; universities were like a newborn—full of promise, innocence, and needs. Yet they survived, and in many cases thrived, filling a void in a never-ending quest to enrich lives.

To this day, optimism and fearlessness abound at the University of Nebraska, creating a spirit that breaks through conventions. Like the people noted in this book, Nebraskans don't coddle an identity or way of being. We look challenges and opportunities in the eye and apply fresh thinking, collaboration, and creativity to forge new paths. We are proud of our accomplishments, but there's little pretense on the prairie; we are accessible, open, and honest people. The expansive geography around the University of Nebraska fosters a closeness here that makes way for solutions and has us convinced that we're in the middle of everywhere. Kay adeptly and richly illuminates the fascinating detail of our history in reaching across spaces, closing real or imagined distances, to get more done in our state and around the world.

—Ronnie D. Green, PhD
Chancellor

ACKNOWLEDGMENTS

There are many people I would like to thank for their assistance with this project. First, I would like to thank Nancy Busch, dean of libraries, for her financial assistance and willingness to allow me time to research and write this book. I am grateful to my colleagues in university archives for tolerating my endless requests for images, in particular Josh Caster, who spent hours locating images. Thanks also to John Wiese for assistance with image files, to Jacqueline Groves for holding down the fort in my absence, and to Richard Graham for covering my duties while I was busy writing. And special thanks to Chancellor Ronnie Green for his enthusiastic support and willingness to pen the foreword.

I received kind assistance from University Communications; Les Valentine, University of Nebraska–Omaha archivist; Martha Miller, Nebraska State Historical Society; and Emily Levine in my search for early farm images. Emily shares my zeal for documenting the campus and its evolution. Liz Gurley, my editor at Arcadia Publishing, was unfailingly supportive.

I especially want to acknowledge the many authors who preceded me in documenting the long and colorful history of our university, in particular Robert Knoll, who authored *Prairie University* in 1995, just as I was beginning my own early research into the university's past. Thank you, Robert, for your encouragement.

All images are from University Libraries Archives and Special Collections Department, University of Nebraska, unless otherwise noted.

INTRODUCTION

When Pres. Abraham Lincoln signed into law the Morrill Land Grant Act of 1862, the course of higher education in the United States was altered forever. Democratic in intent, the language of the Morrill Act states that the purpose of land-grant universities is to "promote the liberal and practical education of the industrial classes in the several pursuits and professions in life." Viewed by many as primarily a system to provide agricultural education, the act was in reality much broader and included "mechanical arts," now known as engineering, "military tactics," and "other scientific and classical studies." Newly formed states in the western United States, with their democratic ideals and relatively classless societies, provided the perfect environment in which this new kind of education could flourish.

The establishment of the University of Nebraska in 1869 was characterized by the zeal and optimism of the young state's early citizens. When legislators met for the first time in the new capital of Lincoln, most were determined to make the new city a success, acting quickly to locate not only the capitol but also the penitentiary, the state asylum, and the state university in Lincoln. In what would later be viewed as a visionary decision, legislators determined that the state university and the land-grant-funded state agricultural university should "be united as one educational institution." This decision was likely driven more by economics than vision but proved to be advantageous in the decades that followed.

Nebraska legislators were eager to take advantage of the financial benefits of the Morrill Act and approved the creation of the university on February 15, 1869. The entire legislative process, including approval by two committees and both the house and senate, took just five days. A recommendation from the Public Buildings Commission to locate the new university on a tract of prairie north of the nascent downtown was brought forward and approved without much debate, although many more logical and attractive locations were readily available. The four city blocks that were chosen proved to be problematic; the new university lay directly in the path of the railroads, even then building toward the capital city. The selection of the site prevailed, however, and the university remained at the intended site.

Not all of Nebraska's citizens and legislators supported the early university. Some believed the state had more pressing problems and could ill afford the establishment of such an expensive enterprise. Omaha and Nebraska City still harbored ill feelings about the relocation of the capital to Lincoln, and J. Sterling Morton in particular opposed the move and the university by association. The construction of University Hall and its attendant problems only added fuel to the fire. Cost overruns, questionable business dealings,

poor-quality work, and low enrollment all contributed to suspicions regarding the early university, but it prevailed and eventually began to thrive.

The early university was expected to operate on income generated from lands provided through the Morrill land grants. This system provided public lands, in Nebraska's case 90,000 acres, to be either sold or leased for income. The state also received public land upon achieving statehood for the establishment of a state university. The combined acreage provided a total of 136,080 acres. Income from these lands formed the permanent endowment fund for the operation of the early university. There was, however, never enough money.

Nebraska was young, and most of the state was unsettled except in the eastern parts. The population at statehood was around 100,000 settlers, with thousands of natives living on reservations. Lincoln had a population of around 1,000 people, all newcomers. Few were deeply concerned with the building up of the university in the face of so many pressing needs and decisions. Early advocates like Charles Gere, senator, regent, and newsman, kept the needs of the university in the public eye, but it was sometimes a lonely battle, and funding from the state was limited.

Eventually the little prairie university entered its adolescence. By the turn of the new century, it had made strides in instruction, increased faculty and enrollment, and added new campus facilities and improvements. Strong leadership from men such as Chancellor James Canfield, Prof. Charles Bessey, and a talented faculty garnered national recognition for the university. The Nebraska Cornhuskers were establishing themselves as a football powerhouse. The university farm evolved into an instructional campus focusing on agriculture and home economy. The trajectory for the University of Nebraska was decidedly upward. In 1896, the graduate college was organized, the first west of the Mississippi River. In 1908, the university was admitted into the prestigious Association of American Universities.

Predictably, there were great successes as well as setbacks and difficulties. In the years immediately following World War I, enrollment flourished, and the newly expanded campus filled with modern buildings. During the Great Depression, enrollment stagnated, as did the university as a whole. Following World War II, thousands of veterans arrived on campus, presenting new challenges for administrators and faculty. The 1960s brought the children of those veterans in unimaginably high numbers, questioning everything, including the established way of running a large university. Times were changing, students were changing.

In 1968, the University of Nebraska became a multi-campus institution. Although the College of Medicine had been located in Omaha since the first decade of the century, all undergraduate instruction occurred in Lincoln. The addition of the municipally owned Omaha University, renamed the University of Nebraska at Omaha, marked a major transition in the history of the university. No longer a campus but part of a system, the university was managed by a centralized administrative unit. The Lincoln campus became the University of Nebraska–Lincoln, the flagship campus of the university system. Kearney State College joined the system in 1991, becoming the University of Nebraska at Kearney.

Today, as the University of Nebraska approaches its 150th year, the Lincoln campus has an enrollment of more than 25,000 students. Its two campuses in Lincoln cover more than 600 acres and administer agricultural research centers across the state. In 2011, the University of Nebraska became a member of the Big 10 Conference and Academic Alliance. It is designated a Carnegie R1 research university and has a graduate enrollment of more than 5,000 students.

One

FOUNDING A PRAIRIE UNIVERSITY

In the 1870s, most Nebraskans were working hard to build new lives on the unsettled prairie and gave little if any thought to the university's creation and well-being. Public schools, still in their infancy, were struggling to get organized. These schools were considered of more pressing importance to pioneer families than a new university many miles away. In September 1871, when the university opened its doors, 130 students matriculated, although only 20 took university-level course work, the remainder being enrolled in the preparatory school. Many of these students were from Lincoln or nearby towns.

The establishment of the University of Nebraska took only five days to work its way through the legislature, but the ease with which the university came into existence was not indicative of its early progress. The first leaders of the university were men of high ideals and great ambition, but financial scandal and political feuds hampered early progress. Many felt the university should be a Christian institution, and indeed the early chancellors and faculty were all ordained ministers. Others felt there was too much religion at the public university, even as students were required to attend daily chapel. Lingering regional grudges about the decision to locate the university in Lincoln remained. Financially, the state was dealing with grasshoppers and drought. All these problems were looming when the questionable construction of University Hall became known to the public, further eroding support for the university.

In 1882, when Charles Gere began his 10-year term on the board of regents, the university was finally turning a corner as the state's economy improved. The faculty was expanded, and a new chancellor, Irving Manatt, arrived in January 1884. The move to secularize the university was mostly successful, and modern instructional methods, such as a two-semester elective system, were employed. University Hall was repaired and no longer in danger of collapsing. In August 1884, Charles Bessey arrived in Lincoln to assume the role of dean of the Industrial College, forever altering the path of the young university.

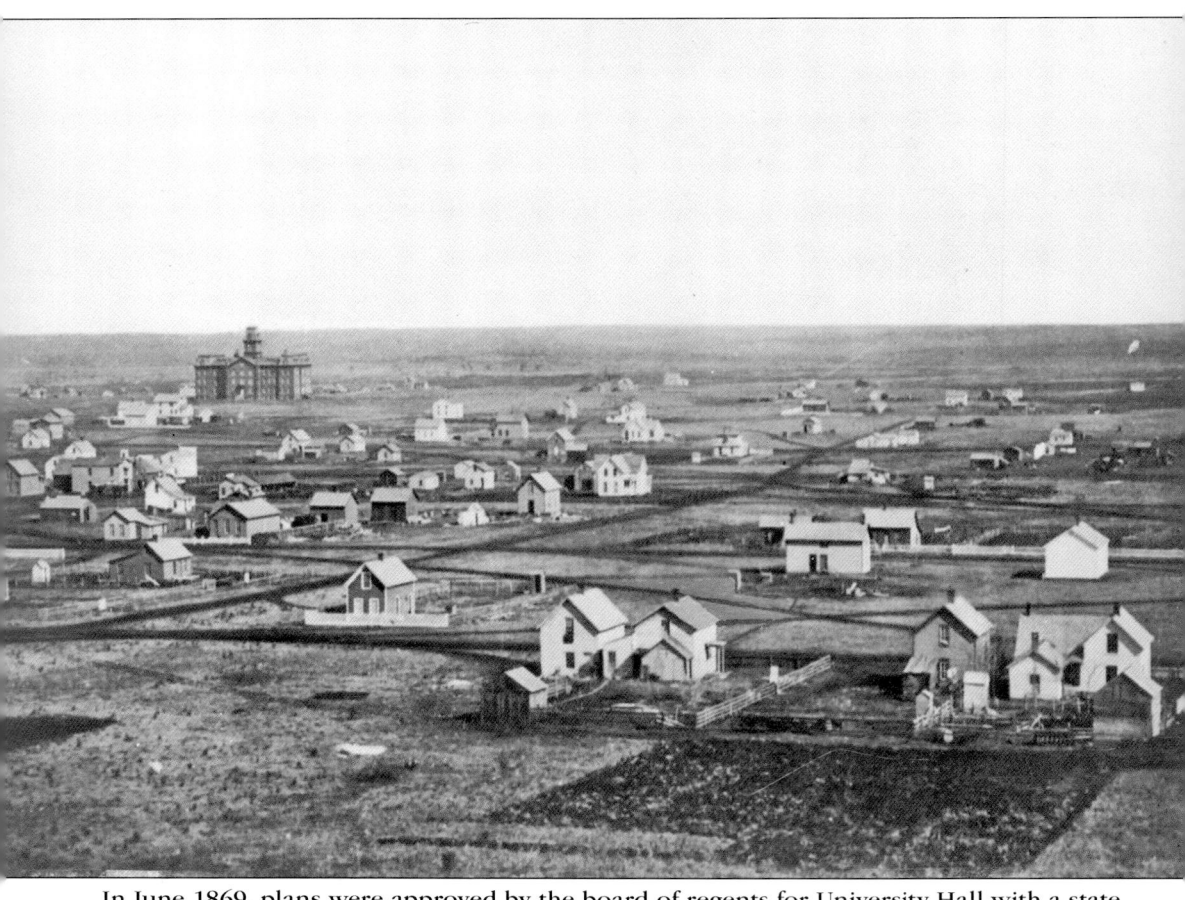

In June 1869, plans were approved by the board of regents for University Hall with a state allocation not to exceed $100,000. The State Buildings Commission, led by Gov. David Butler, hired architect Matthew McBird to provide architectural plans. The architect described his design as Franco-Italianate. In August 1869, contractor J.D. Silver submitted an estimate of $128,480, which was approved by the regents. This action later proved disastrous, particularly for Governor Butler, who was impeached in 1871 at least partly due to the excessive cost of the university.

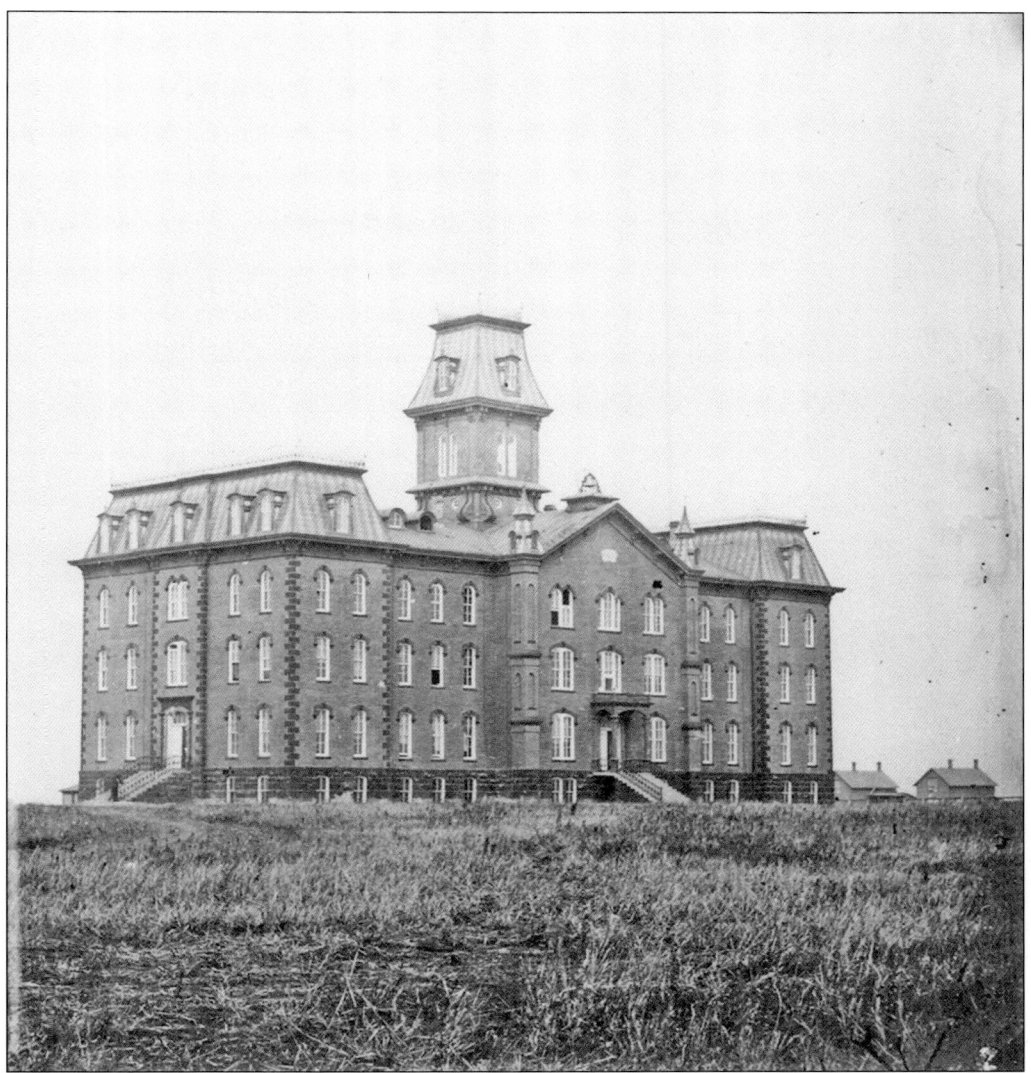

University Hall was the only building on campus from 1871 until 1885. Initially it had no amenities and was poorly heated by a coal-burning furnace. Plagued by poor building materials, the crumbling foundation required replacement before the first classes were held, and roof repairs were ongoing until the roof was completely replaced in 1883. University Hall housed all offices, recitation rooms, the library, the chapel, and crude laboratories. In the very early years, faculty member Frank Billings kept hogs in the basement. University Hall sat in the center of the four-block campus that extended from R to T Streets and Tenth to Twelfth Streets.

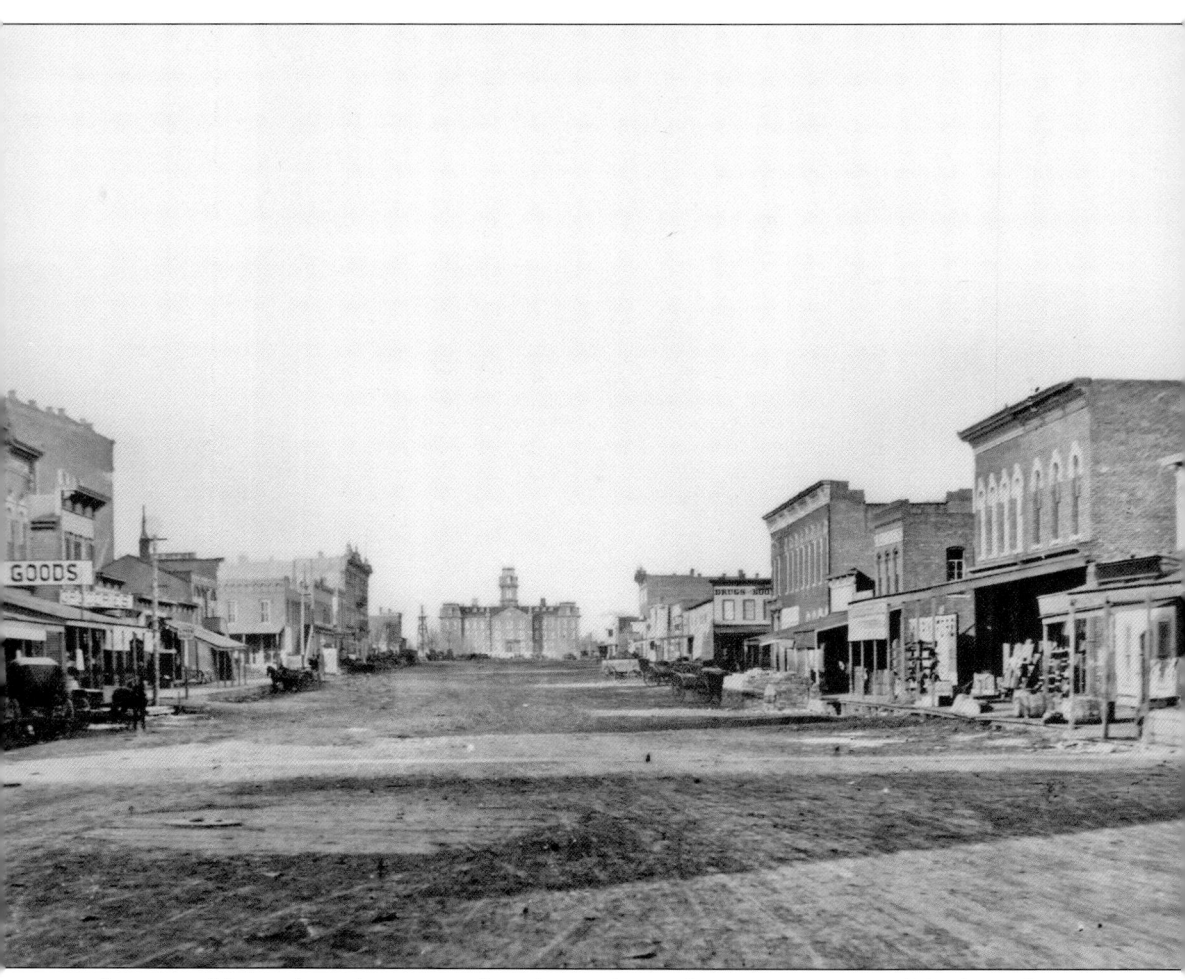

Large and imposing, the new university sat in stark contrast to Lincoln's dusty business district, still in its infancy. When the university was constructed in 1870, Lincoln had no water system, no sidewalks, no paved streets, and no railroad. The university was constructed on unbroken prairie. This 1876 photograph was taken looking north on Eleventh Street from around O Street.

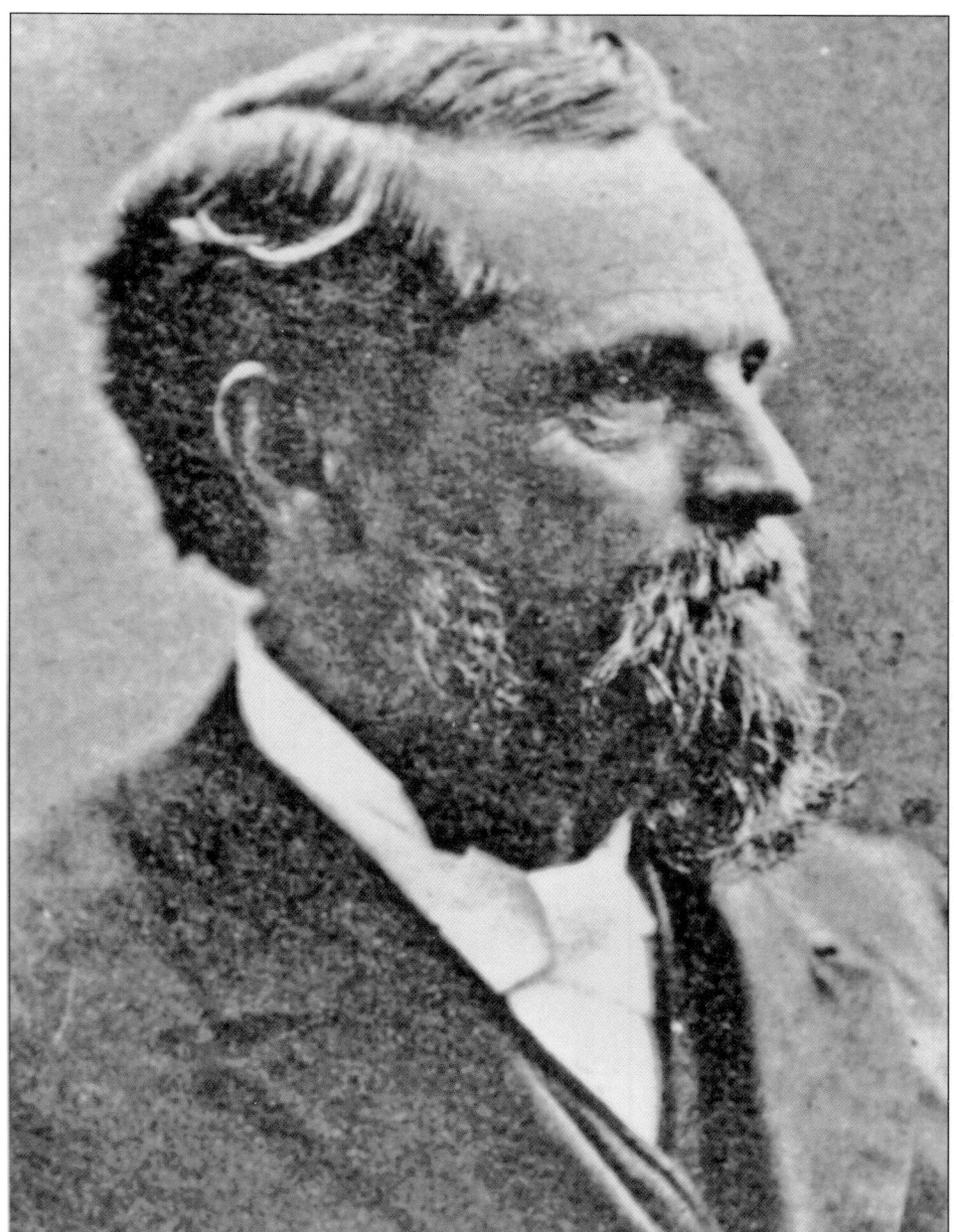

Allen R. Benton was appointed as the university's first chancellor in January 1871. An ordained minister, Benton arrived in Lincoln as "the great Unknown of Indiana," according to the *Omaha Herald*. He was paid an astonishing sum, $4,000, for his work as chancellor. In his first years, he served as an emissary for the new university and visited with any group willing to listen to him. Positive and popular with students, Benton's tenure was marked by legislative power struggles and confusion about the role of religion at the university. Four men were hired as faculty, and all but one were ordained protestant ministers. As a faculty, they did not fully comprehend the intent of a land-grant university. Benton left the university in the summer of 1876, having graduated 10 students.

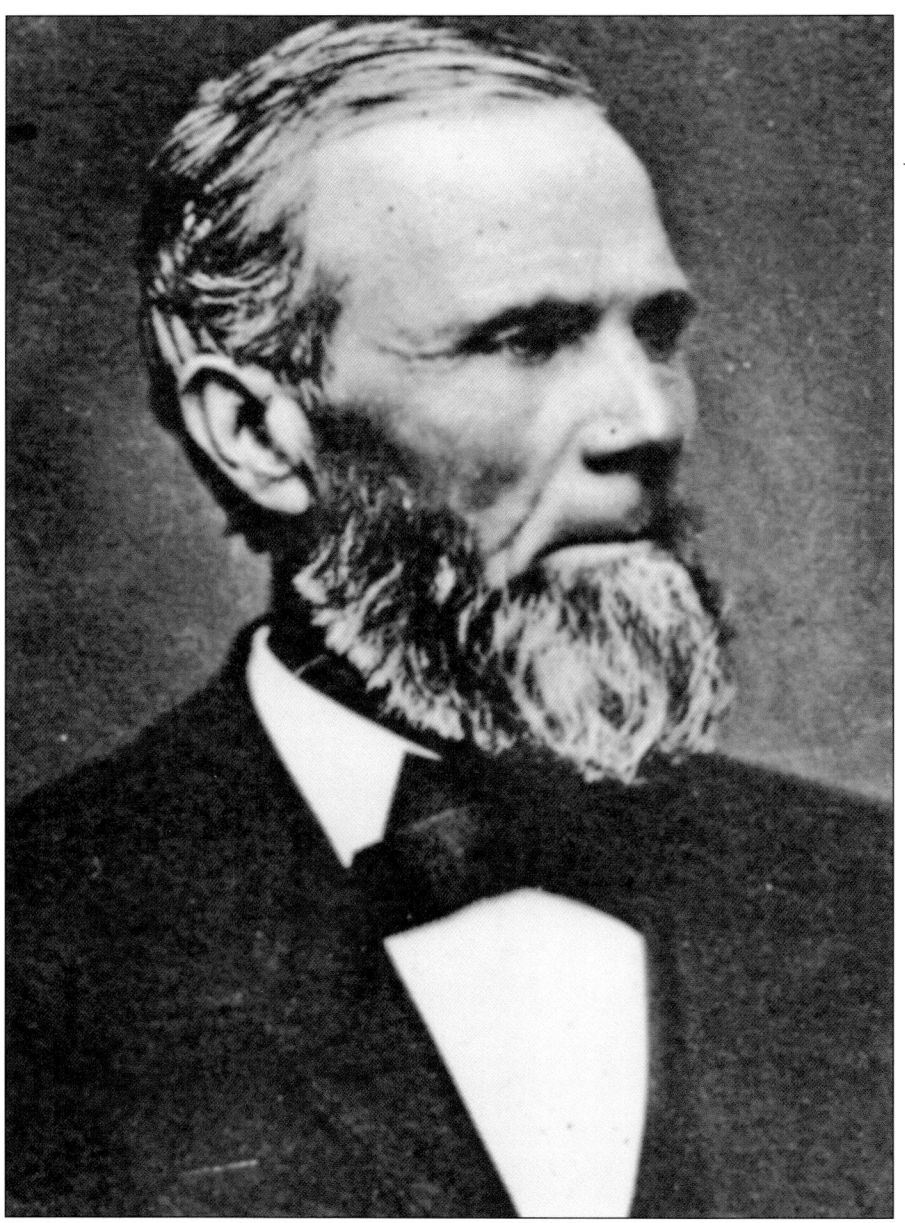

Before Benton had even resigned, the regents offered a contract to Edmund B. Fairfield, a nationally known educator, politician, and minister. Known as a political liberal, he was a traditionalist as an educator. The arguments concerning religion continued unresolved, but the university gained students and faculty during Fairfield's time in Lincoln. He was the first chancellor to add a woman to the faculty with the hiring of Ellen Smith. By the time he was fired in 1882, there were 17 faculty members. Fairfield was pressured to expand the curriculum even though the financial situation during his tenure was precarious. Military training began in 1876 and became mandatory the next year in accordance with the Morrill Act. Fairfield was ultimately undone by a schism among the faculty concerning educational reforms. Mathematics professor Henry Hitchcock was named acting chancellor.

Editor, lawyer, senator, and regent, Charles Gere was the university's first champion. Senator Gere chaired the Committee on Education when the university was founded in 1869. As editor of the *Nebraska State Journal*, he advocated for funding and expansion when the university had few supporters. Gere served as president of the board of regents from 1882 to 1892, steering the university through a transitional period leading to enrollment growth and institutional stability.

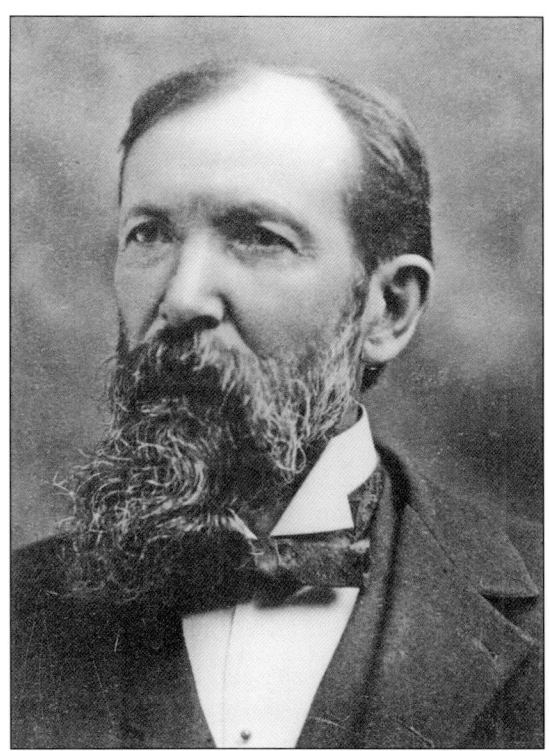

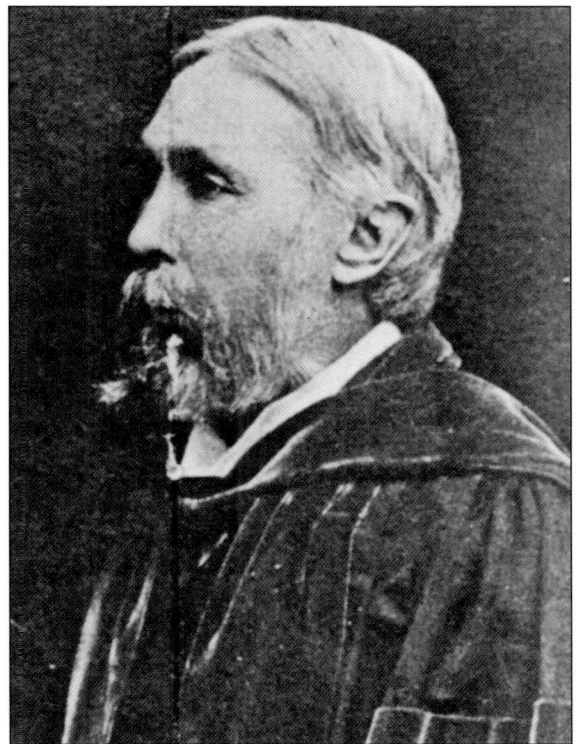

Irving Manatt served as chancellor from 1884 to 1888, pursuing an upward trajectory for the university. Manatt endorsed a course of physical expansion and successfully lobbied the legislature for several new buildings. He doggedly led the charge for more financial autonomy from the legislature as well. A brilliant scholar, Manatt was often sarcastic and contemptuous. In July 1888, he was dismissed by the regents and Charles Bessey was named acting chancellor.

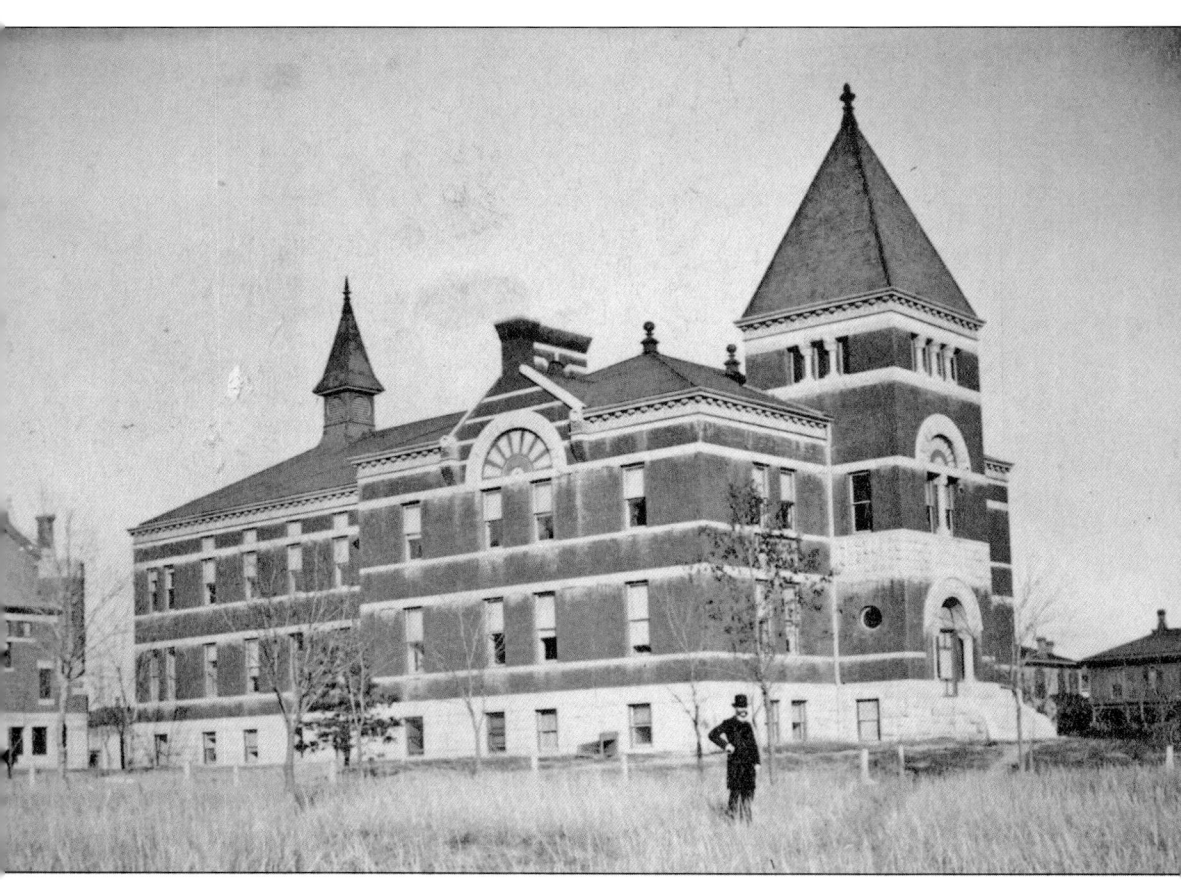

In 1884, Manatt and the regents secured funding from the legislature for a second building, a chemistry laboratory, after determining it to be the most urgent of the university's building needs. Students celebrated the news with a spontaneous parade through downtown Lincoln that continued to the chancellor's home and the capitol. The laboratory opened in 1886 and received heavy use. In 1919, the laboratory was renamed Pharmacy Hall after a new chemistry laboratory, Avery Hall, was constructed. The old chemistry laboratory was razed in 1963 prior to construction of the Sheldon Museum of Art. It was located at the northwest corner of Twelfth and R Streets.

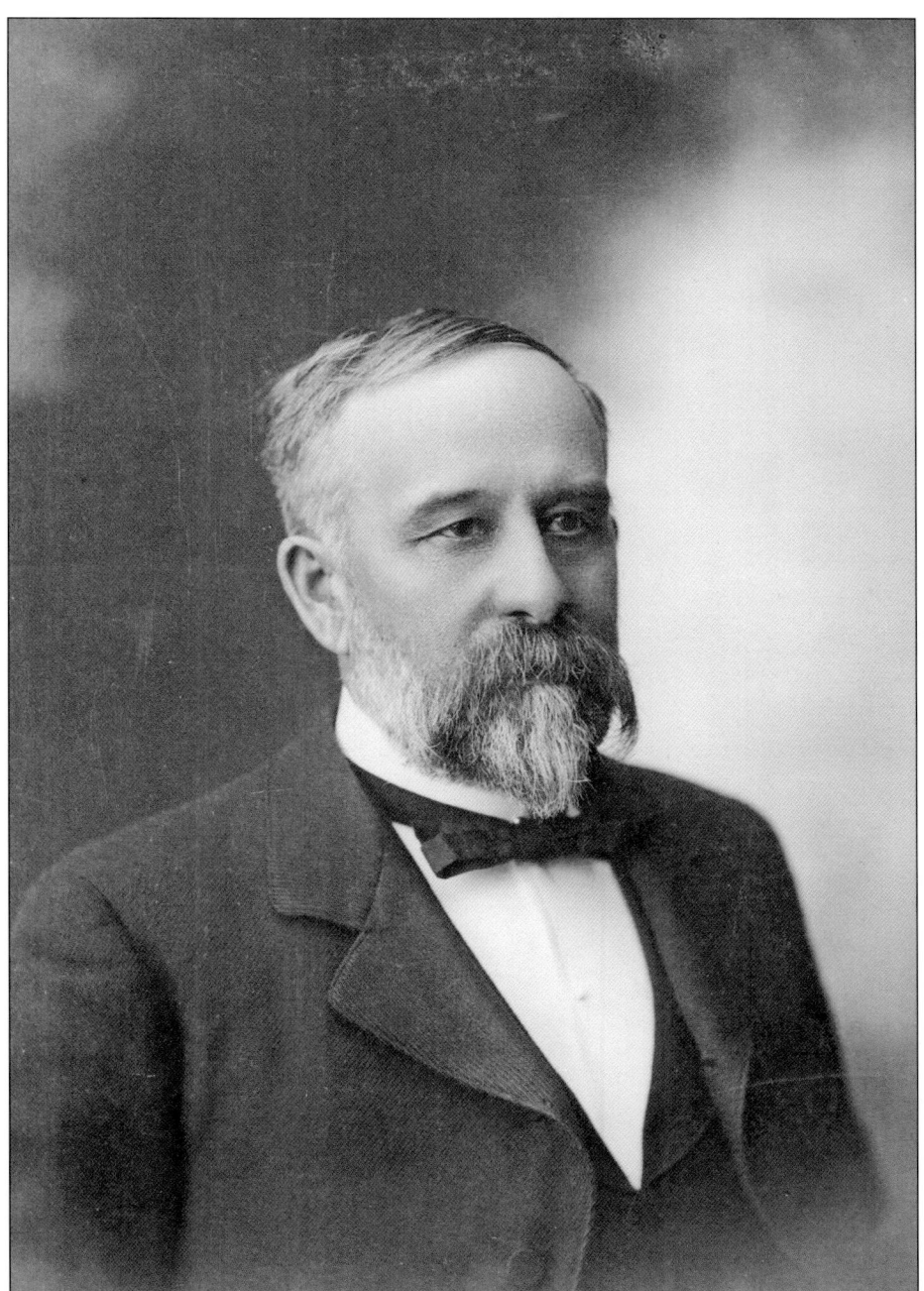

Charles Bessey was the single most influential faculty member at the young university. Hired away from Iowa State University in 1884, Bessey served twice as acting chancellor, as dean of the Industrial College, and for many years as dean of deans. He oversaw development of the university farm and established the agricultural experiment station after co-authoring the national Hatch Act of 1887. Bessey built one of the foremost botany programs in the United States at Nebraska and mentored some of the field's most notable scholars. He was inducted into the Nebraska Hall of Fame in 2007. Bessey is pictured here in 1899.

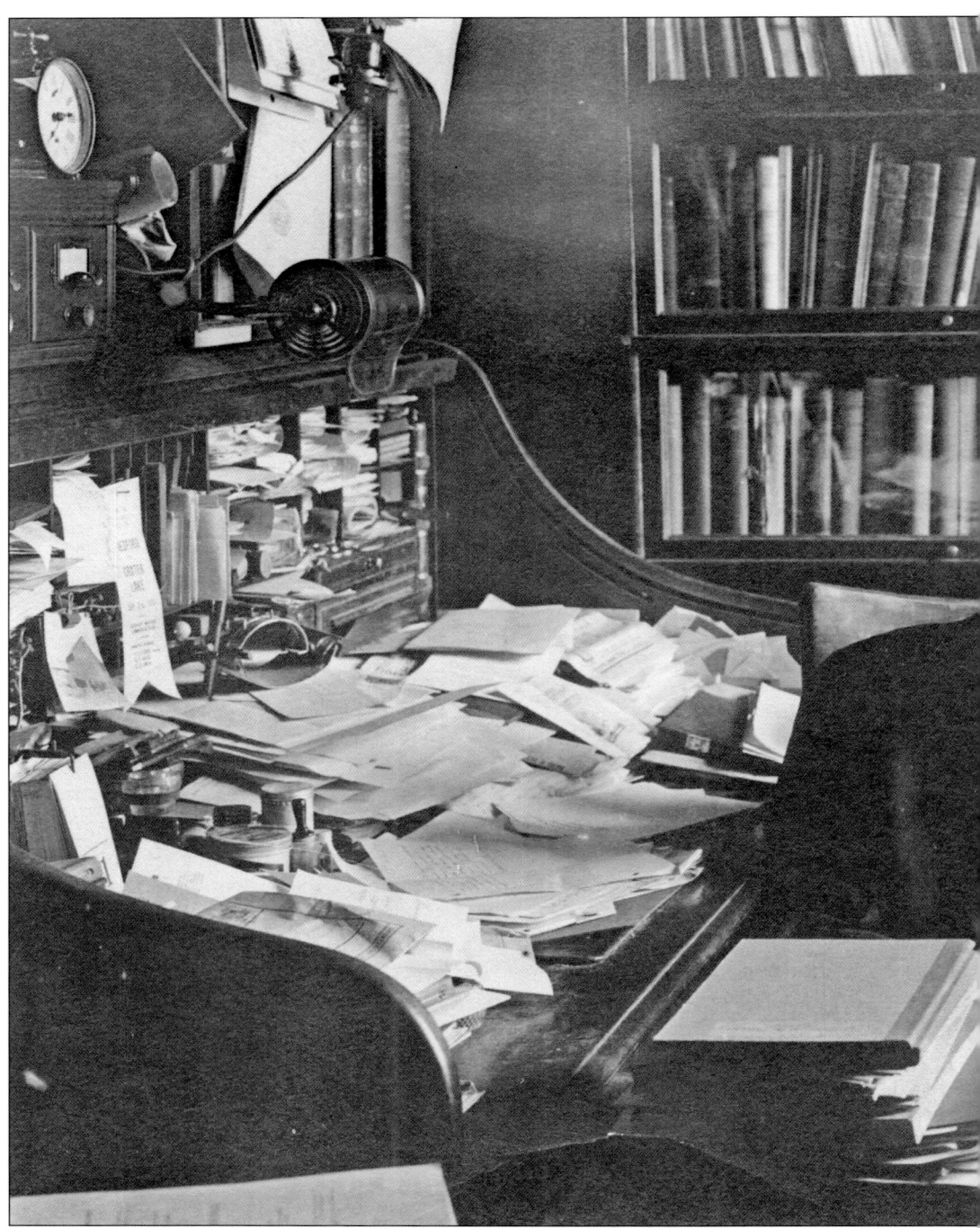

A few years after Charles Bessey arrived in Lincoln, the university constructed Nebraska Hall to house the Industrial College. Bessey developed the motto "Science with Practice" for the new building's cornerstone. He served as dean of the Industrial College and worked in this office in Nebraska Hall for nearly 30 years. He was apparently comfortable with a disordered desk. When the university expanded around World War I, a new building was

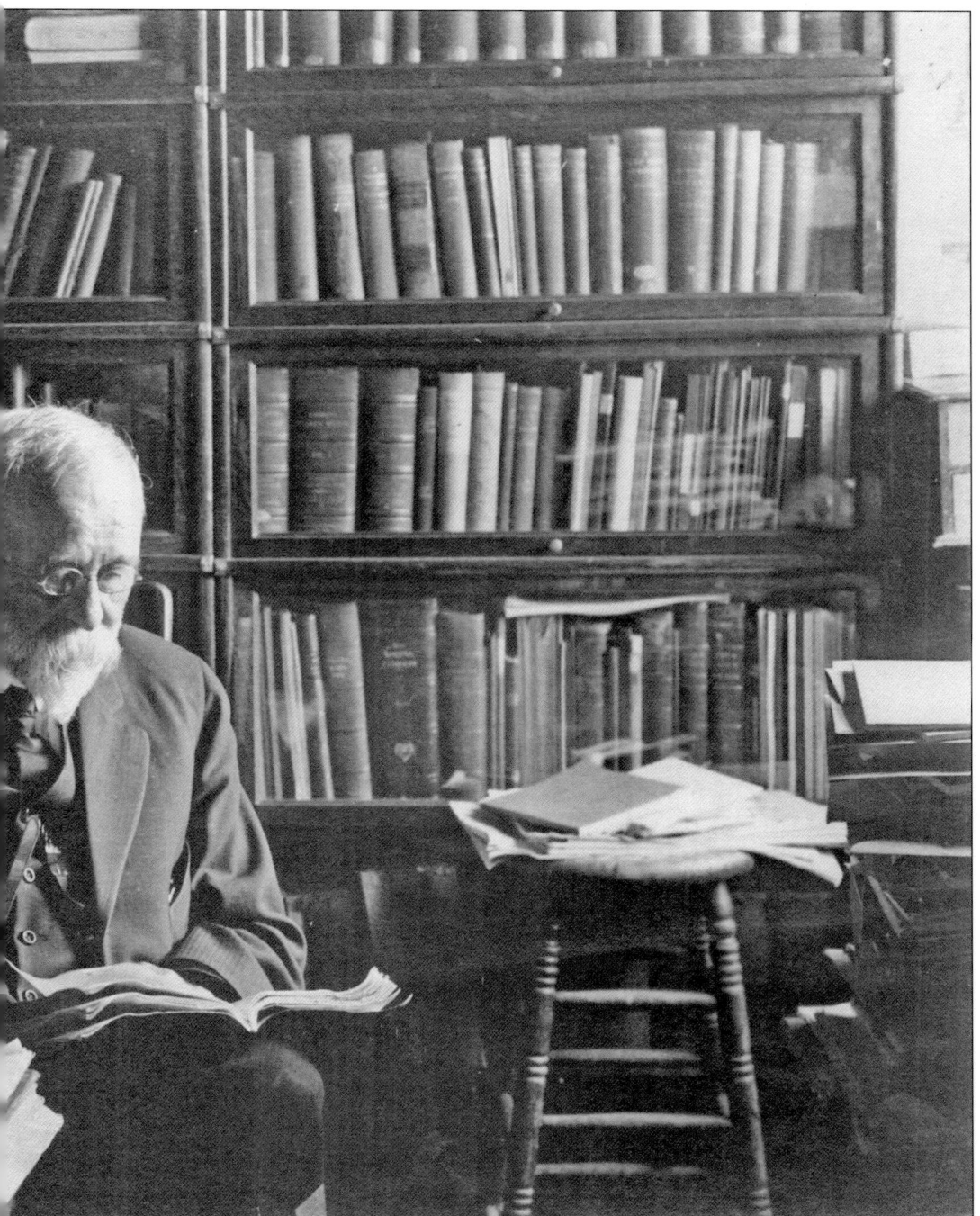

planned to house botany and zoology. Bessey indicated he would prefer an office on the north side of the new building to take advantage of the soft light, but he died in 1915 before the building was finished. The new building was named Bessey Hall in his honor when it opened in 1916.

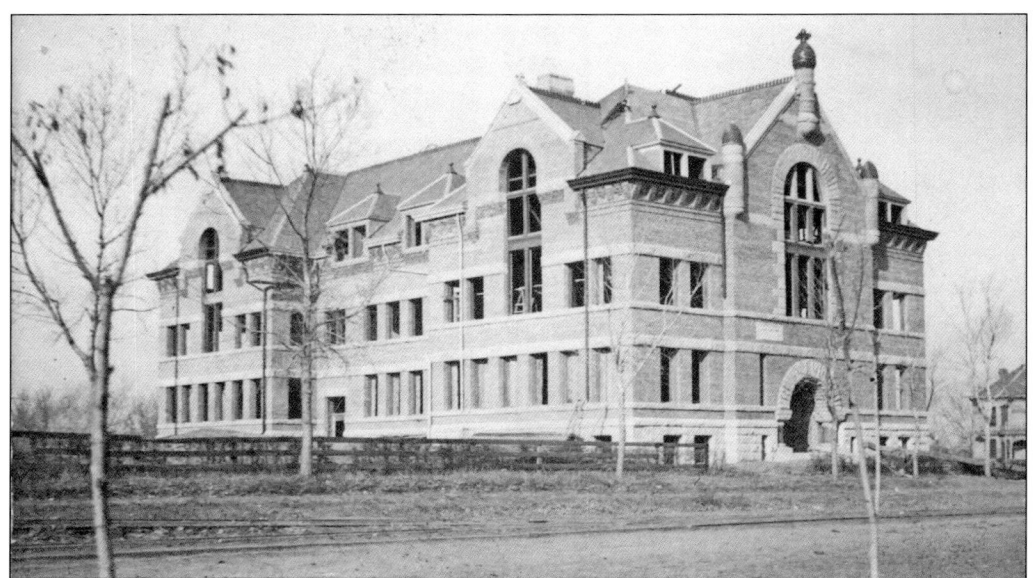

The Industrial College was created in 1877 as a home for agriculture and mechanical arts. Initially it stagnated due to lack of faculty and students. With the arrival of Charles Bessey, the purpose of the Industrial College was clarified and reorganized, and enrollment climbed. In 1887, the first Nebraska Hall was constructed on the northeast corner of campus to house the Industrial College. It is pictured during construction.

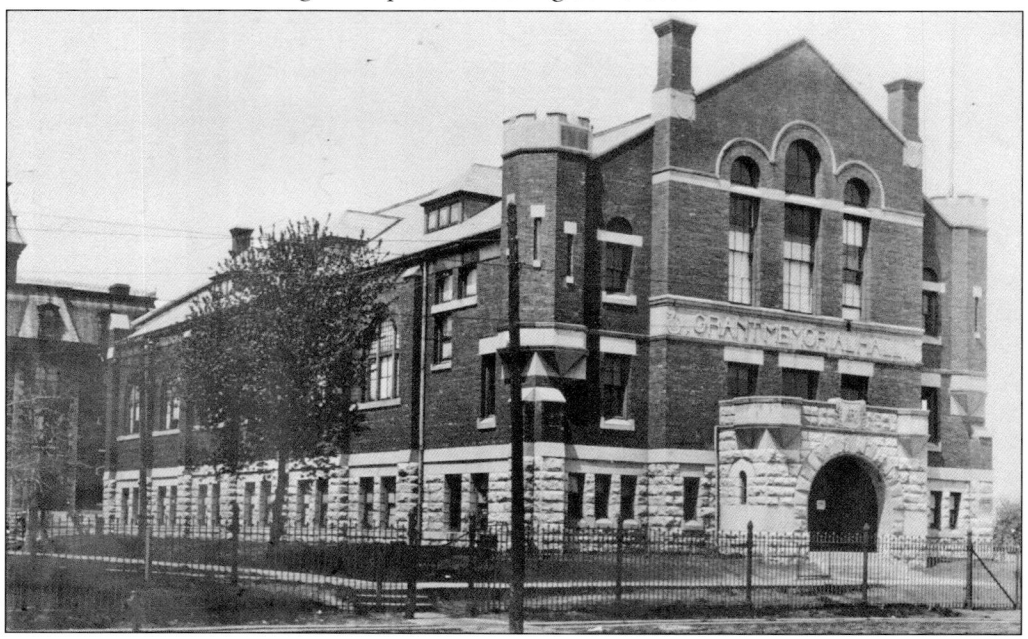

Grant Memorial Hall, often called the armory, was constructed in 1877. It contained a gymnasium that provided space for military drill practices and physical education. A 1900 addition called Soldiers Memorial Hall housed a large pipe organ built for the Trans-Mississippi Exposition, held in Omaha in 1898. The addition provided an auditorium for the campus. It was located on Twelfth Street and was razed in 1966.

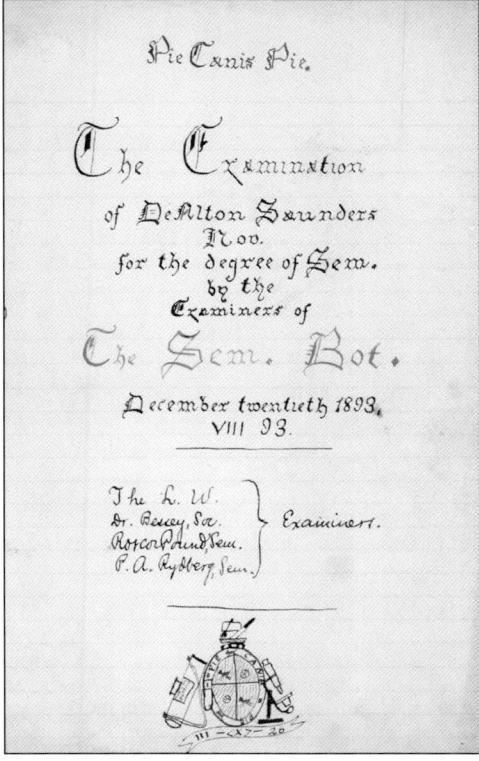

The Seminarium Botanicum, or Sem Bot, was informally established by Bessey and several students, including Roscoe Pound, in 1886 as a scientific club. Sem Bot created levels of membership that were attained based on knowledge of botany. Members collected and studied plants and campaigned against "lits and philistines" (literary and classical studies). Later, Sem Bot held formal meetings and undertook the botanical survey of Nebraska, eventually publishing *The Flora of Nebraska*. Above is the Sem Bot with Roscoe Pound (standing, far left) and professors Bessey (seated, center right) and Lawrence Bruner (seated, far right). At right is a handwritten examination announcement signed by Bessey and Pound in 1893.

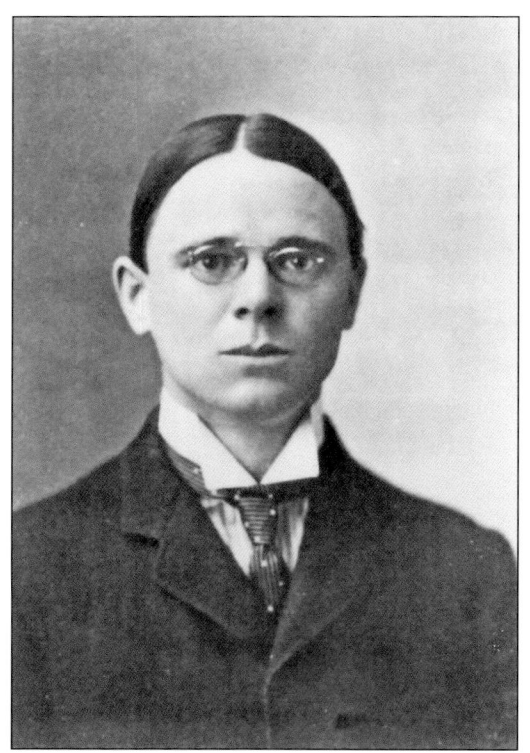

Roscoe Pound graduated from Nebraska in 1888 when he was 18 years old and received his master of arts degree in botany the following year. The son of a Lincoln judge, Pound was a precocious student. He was a founding member of Sem Bot and participated in the cadet corps. In 1889, he studied law at Harvard. He returned to Lincoln within the year and passed the Nebraska Bar in 1890. He then established a highly successful legal practice. While practicing law, he earned a doctorate in botany in 1897, studying under Bessey. In 1898, he published *The Phytogeography of Nebraska* with Frederic Clements, earning them international recognition among botanists. Pound taught law at Nebraska in 1899 and became dean of the College of Law in 1903. From 1916 to 1936, Pound served as dean of Harvard Law School. He is pictured at left in 1888 and below in 1910.

Two

THE BEST IN THE WEST

The University of Nebraska came of age in the 1890s. Battles for its existence were finally put to rest and the legislature became more supportive, despite the financial panic of 1893. Nebraska's public schools were producing well-trained students who could succeed as university students; accredited high schools quadrupled in the 1890s.

Charles Bessey became acting chancellor in 1888 and continued to lead the university until he insisted that the regents hire a new chancellor. Bessey recommended James Canfield of the University of Kansas. Canfield arrived in Lincoln in June 1891.

James Canfield was a man of boundless energy. He saw his role as a link between the citizens of Nebraska and their university. He traveled 10,000 miles a year to speak to clubs and organizations across the state. Due to his outreach, enrollment in the 1890s increased fourfold, reaching nearly 2,000 students. Tuition was free and times were hard; in Canfield's words, "if you cannot earn, you at least can learn." By 1897, Nebraska ranked 14th in size among the 300 universities and colleges in the United States.

Canfield resigned in 1895 to become president of the Ohio State University and recommended George MacLean as his successor. Although MacLean was never as popular as Canfield, his leadership was not inconsequential. Graduate programs expanded; soon, the university was called "the best in the West." The faculty senate was empowered to consider all major policies. MacLean was not able to work with populist regents, and in 1899, he resigned to become president of the University of Iowa.

Bessey assumed the helm once again, but only until the arrival of E. Benjamin Andrews in 1900. Andrews championed academic freedom while stressing the importance of good instruction. A veteran, Andrews was popular with students, who saluted him as he walked about campus. He resigned in 1908 and was replaced by Samuel Avery, a chemist on the faculty. Avery remained chancellor for the next 18 years.

James Canfield's success at building support for the university is indisputable. Arriving from the University of Kansas in 1891, Canfield viewed the role of the state university as "an integral part of the great public school system." He understood the needs and problems facing Nebraskans and believed the university should conduct practical research that would help its citizenry and contribute to the state. Canfield also believed in the power of football to build school unity and pride; in Nebraska, that pride soon extended across the state. During Canfield's tenure, Frank Crawford was hired as the school's first paid football coach in 1893. Canfield oversaw construction of the university's first library building and hired its first professionally trained librarian, Mary Jones. When Canfield announced his resignation in the summer of 1895, his supporters at the university and across the state were shocked and saddened. Canfield left to become president of the Ohio State University.

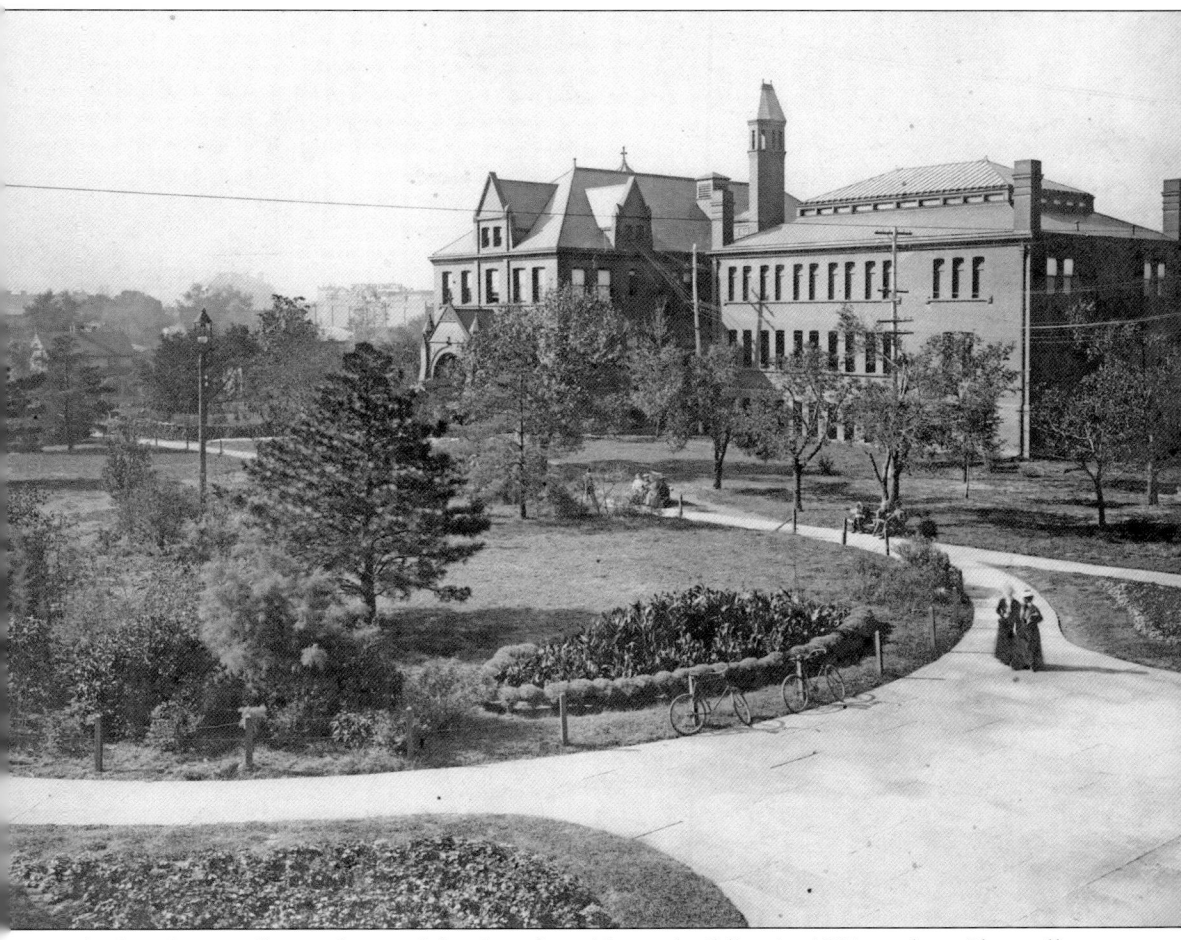

The legislature allocated partial funding for a library building in 1891, and on Chancellor Canfield's arrival, it became his pet project. Construction ceased in 1893 when the building was half finished, due to an interruption in funding. This led the *State Journal* to refer to it as "that melancholy ruin," since it had no front door and a temporary roof. In 1895, the library was completed and was considered to be a brilliant success. Initially, the basement was occupied by the historical society, and the upper level housed the art department until the 1920s. The library building was renamed Architecture Hall when Love Library opened in 1945. It is the oldest building on the city campus and is listed in the National Register of Historic Places.

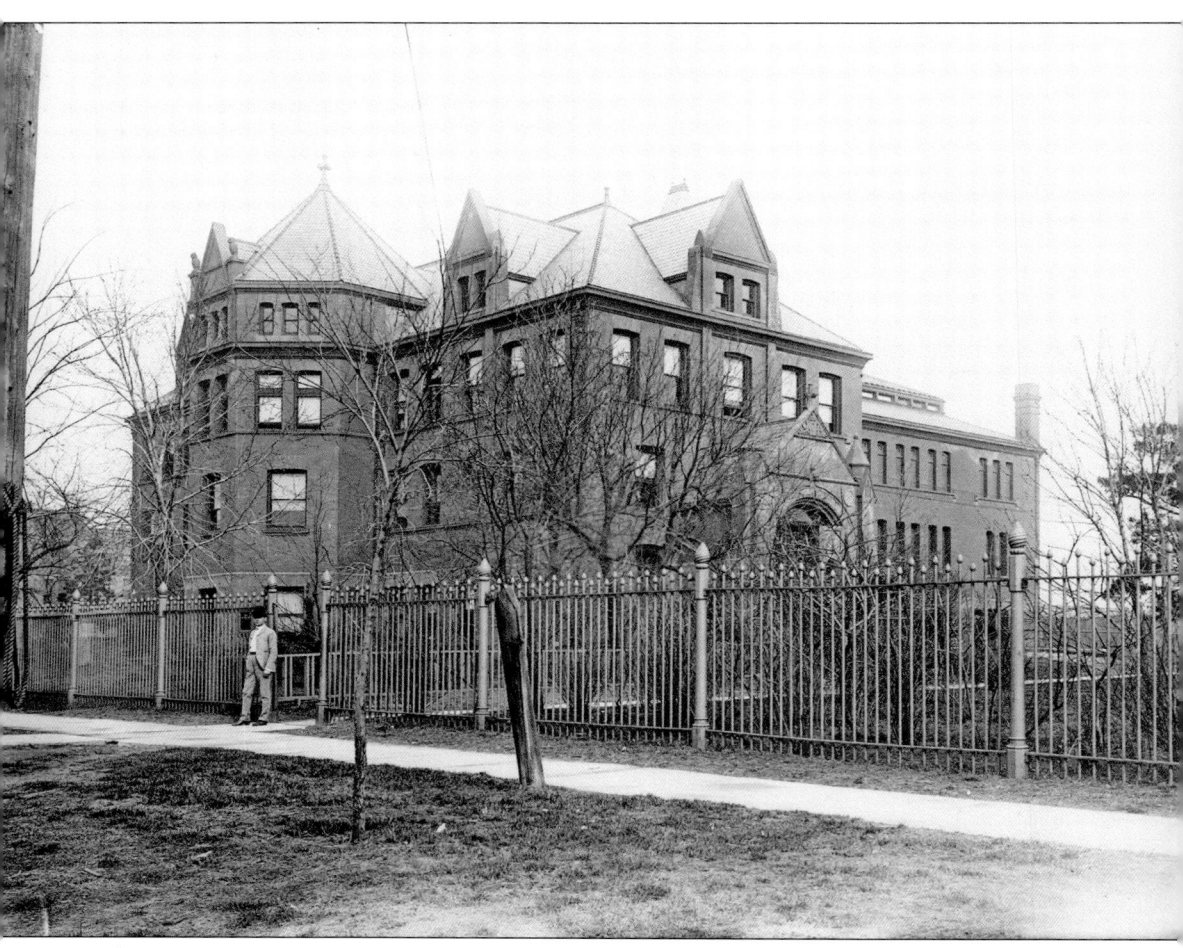

The university campus underwent improvements during the summer of 1891. Included were a system of walks and drives, some landscaping, and the erection of an iron fence with decorative gates that surrounded the entire campus. The fence set the campus apart as a place of culture and learning and kept neighbors from driving their wagons on the grounds. It remained when the campus expanded after 1914 but was removed in 1922 because it impeded fire trucks. The fence now surrounds Wyuka Cemetery in Lincoln, and the decorative gates are located on campus near the columns. Pictured are the fence and library around 1900. (Nebraska State Historical Society.)

By 1873, two students had completed the requirements for graduation. One was J. Stuart Dales, founder of the Palladian Society. Dales had followed first chancellor Allen Benton's family from Ohio, then married Benton's daughter Grace. In 1875, Dales began working for his father-in-law in university administration. Eventually, Dales was responsible for all financial and business dealings and was secretary to the regents. He remained at the university for 57 years.

George MacLean served as chancellor from 1895 to 1899. A Yale graduate, he was unpopular with students due to his formality and his refusal to employ women in faculty roles. During his tenure, the Graduate College and the School of Agriculture were formed, and the preparatory, or Latin, school was eliminated. Populist regents objected to his preference for faculty with eastern pedigrees.

E. Benjamin Andrews became chancellor in 1900. Considered a nationally important figure in education, he was a favorite with Nebraska populists due to his pro-silver stance. When he arrived, enrollment had passed 2,200. Eight years later, enrollment exceeded 3,600. Andrews endorsed the concept of academic freedom for faculty and an elective system for students. He fought for increased funding and acquisition of land for future expansion.

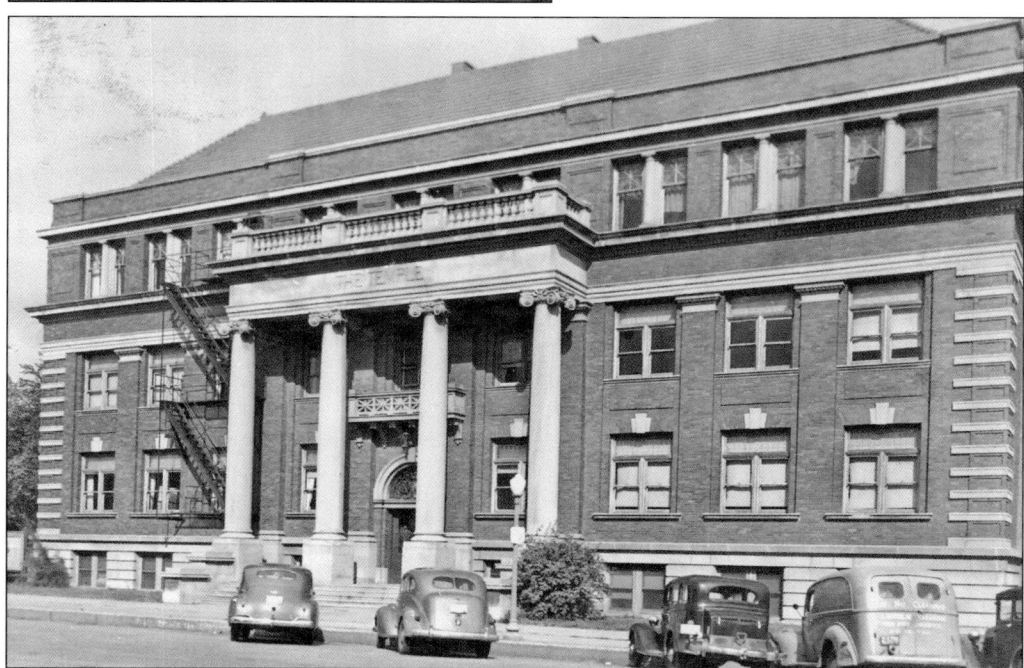

In 1903, Andrews purchased and donated two lots on R Street for the future site of the Temple. He hoped to provide space for student activities and groups such as the YMCA. Funding was partially donated by the Rockefeller Foundation, creating a local scandal due to negative publicity regarding the foundation's oil business. The building opened in 1908; Temple High, later called University High, was located in the basement.

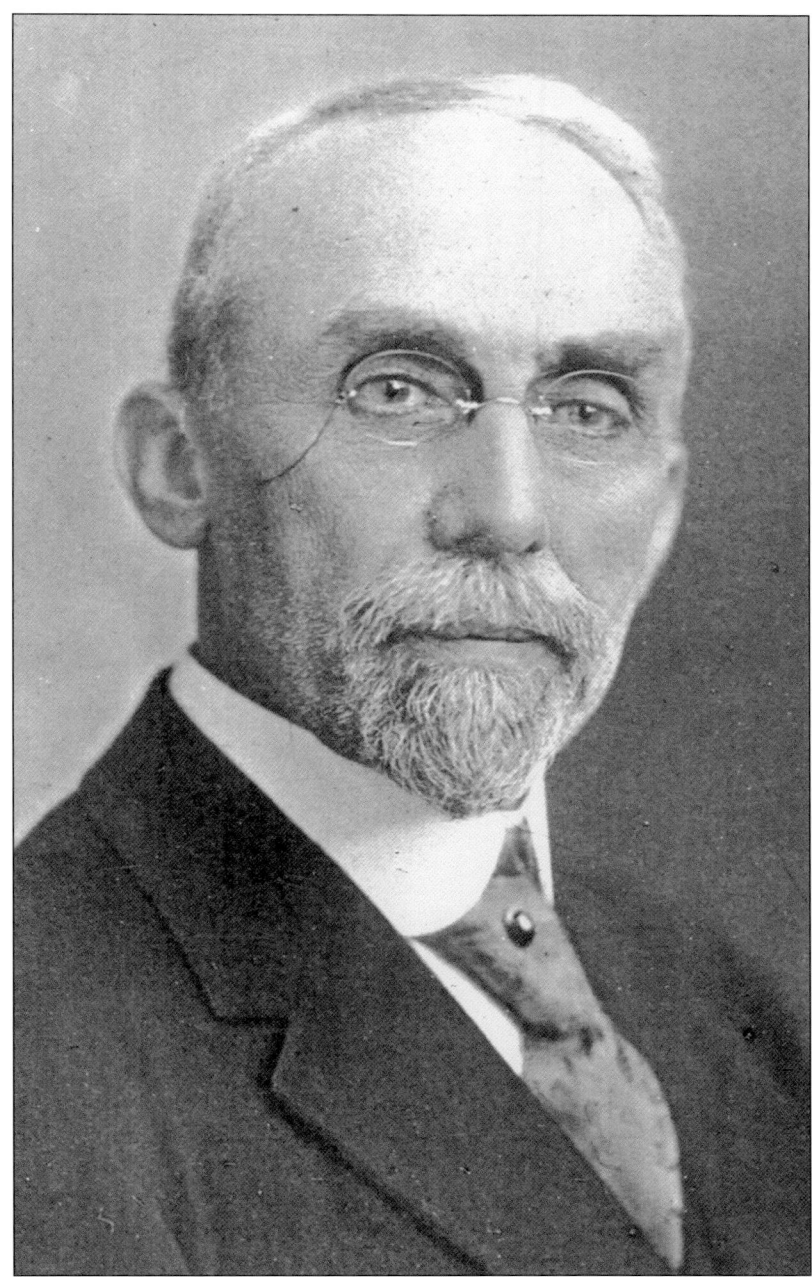

Erwin Barbour joined the faculty in 1891 as a professor of geology and zoology and soon became director of the museum. A graduate of Yale, Barbour spent 50 years at Nebraska, retiring in 1941 when he was 85. A man of boundless energy, he befriended Charles Morrill and interested him in underwriting fossil-finding expeditions in western Nebraska. This relationship also resulted in the construction of two natural history museums, including the current Nebraska State Museum in Morrill Hall. Barbour participated in many organizations in Lincoln and was a well-known figure around town. He was involved with the Boy Scouts and served on the school board and the city planning commission. He died in 1947.

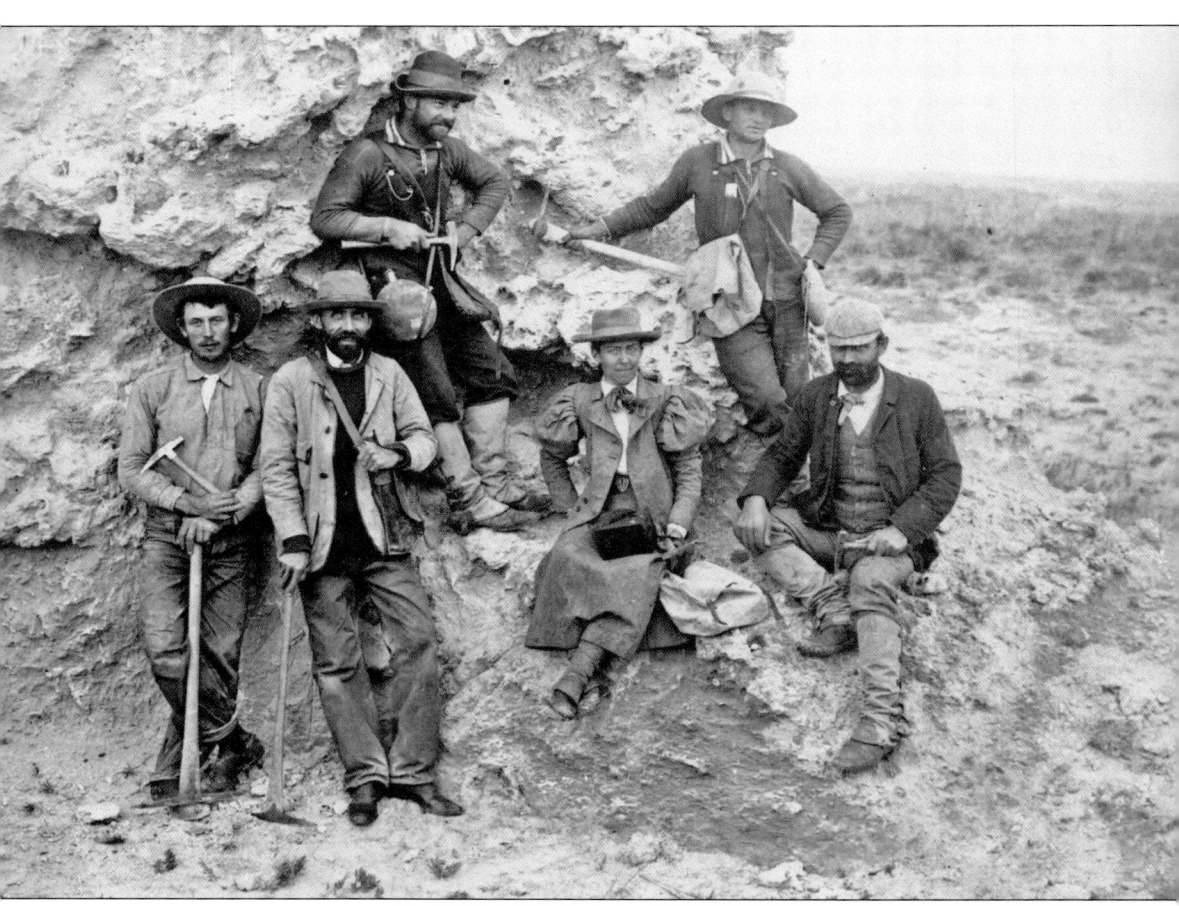

During summers, Barbour led fossil-finding expeditions to Harrison County, Nebraska, at what is now Agate Springs National Monument. In all his endeavors, he was assisted by his sister Carrie Barbour. The expeditions, named the Morrill Geological Expeditions, enabled the acquisition of materials that form the foundation of the collections of the Nebraska State Museum. Most excavation was undertaken on property owned by the James H. Cook family. Barbour's daughter would eventually marry Cook's son. Here, Barbour is second from left with his crew on a fossil-finding expedition in 1897. His sister Carrie Barbour is seated, wearing a skirt.

Charles Morrill served on the board of regents for 12 years, 1890–1902, including a decade as president. Morrill arrived in Nebraska in 1873 and established a farm at Stromsburg. He later became wealthy in banking and as a land agent for the Burlington Railroad. He funded the Morrill Geological Expeditions for many years and provided some of the funding for Morrill Hall, which houses the Nebraska Museum of Natural History.

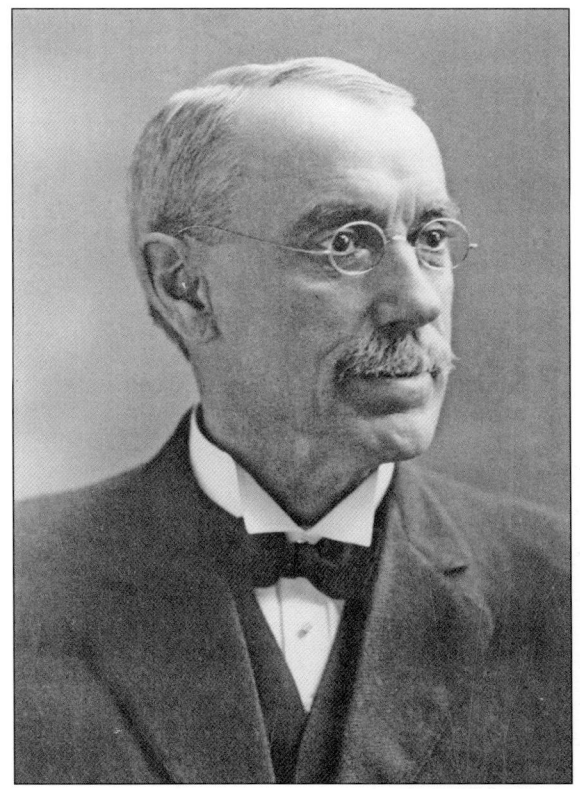

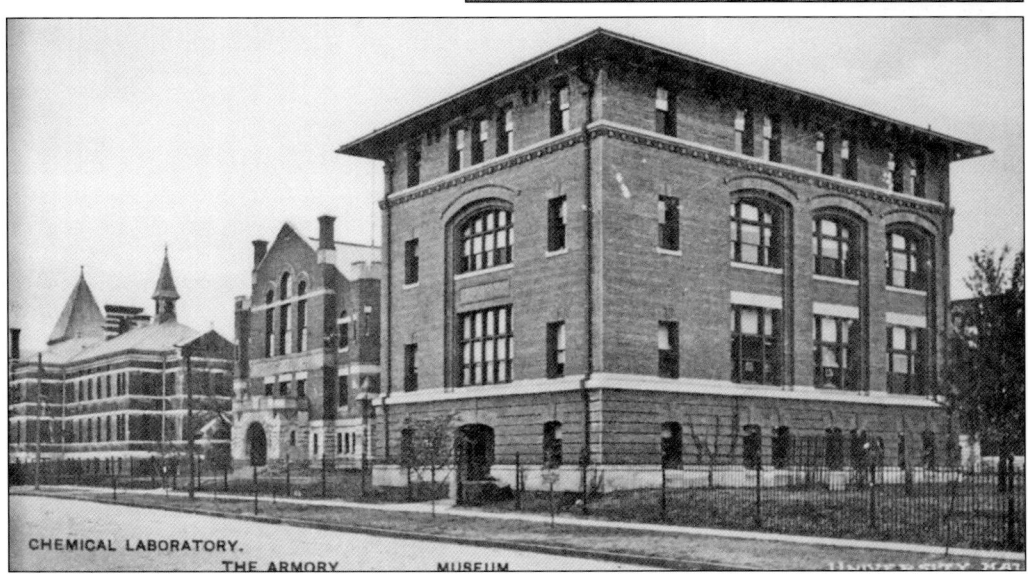

In 1905, Chancellor Andrews recommended Omaha architect Thomas Kimball to design a fireproof museum to house the natural history collections acquired by Barbour. A wing of what was to be a much larger building was constructed but never completed. In 1912, faulty wiring started a fire in the stairwell. Eventually, Morrill Hall was constructed to replace this museum. It was located on Twelfth Street north of Grant Hall.

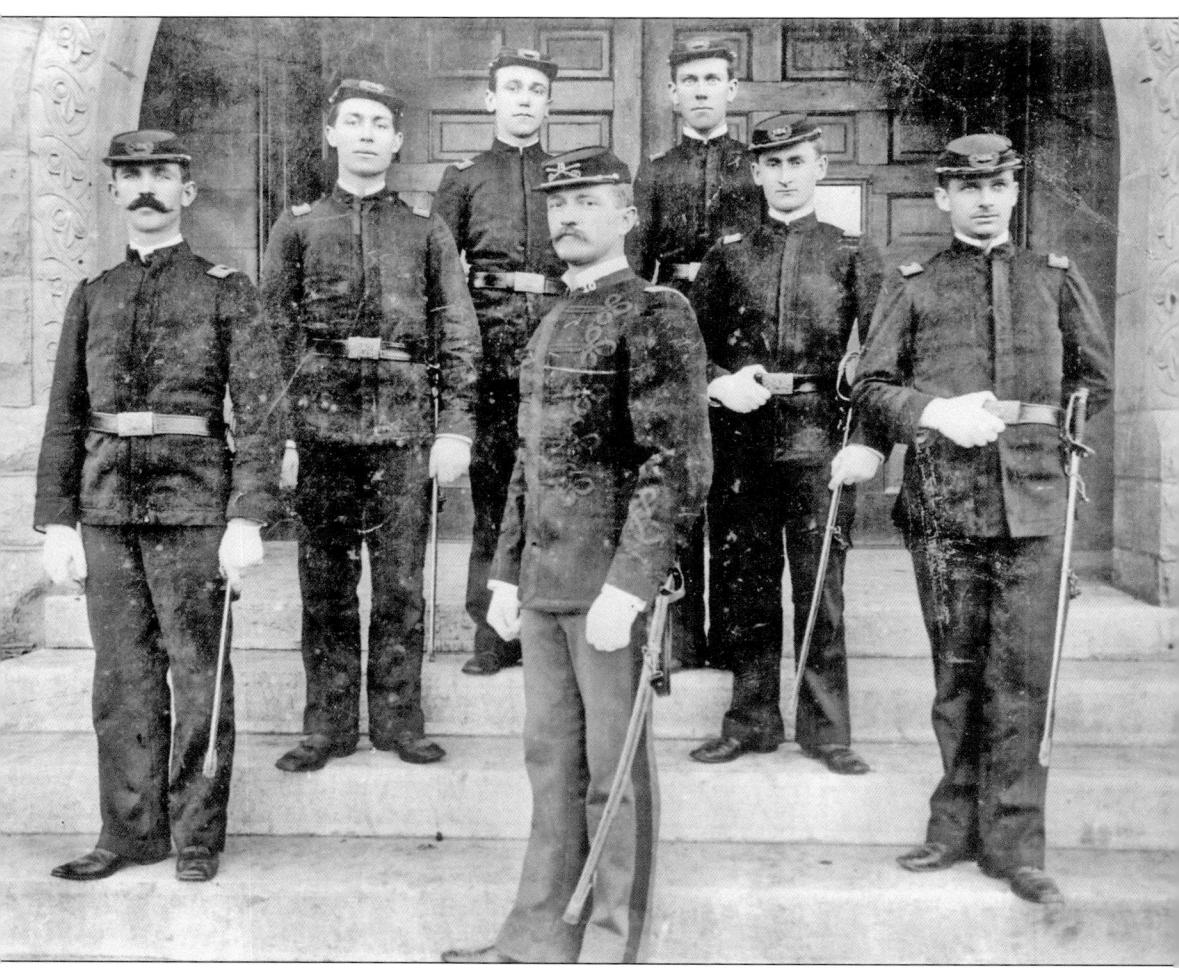

Lt. John J. Pershing arrived in Lincoln in 1891 as professor of military science and tactics. While Pershing was in Lincoln, Chancellor Canfield urged him to study law, which he did, graduating in 1893. Pershing, a graduate of West Point, was a stern leader but beloved by his cadets. When he departed in 1895 to command a troop of Buffalo Soldiers, his select drill company, the Varsity Rifles, renamed themselves the Pershing Rifles in his honor. Pershing went on to become one of the most decorated soldiers in American history and served as commander of the American Expeditionary Forces in Europe during World War I. Pershing (center) is pictured in his early 30s with a small group of cadets on the stairs of Grant Hall around 1894. (*Lincoln Journal Star*.)

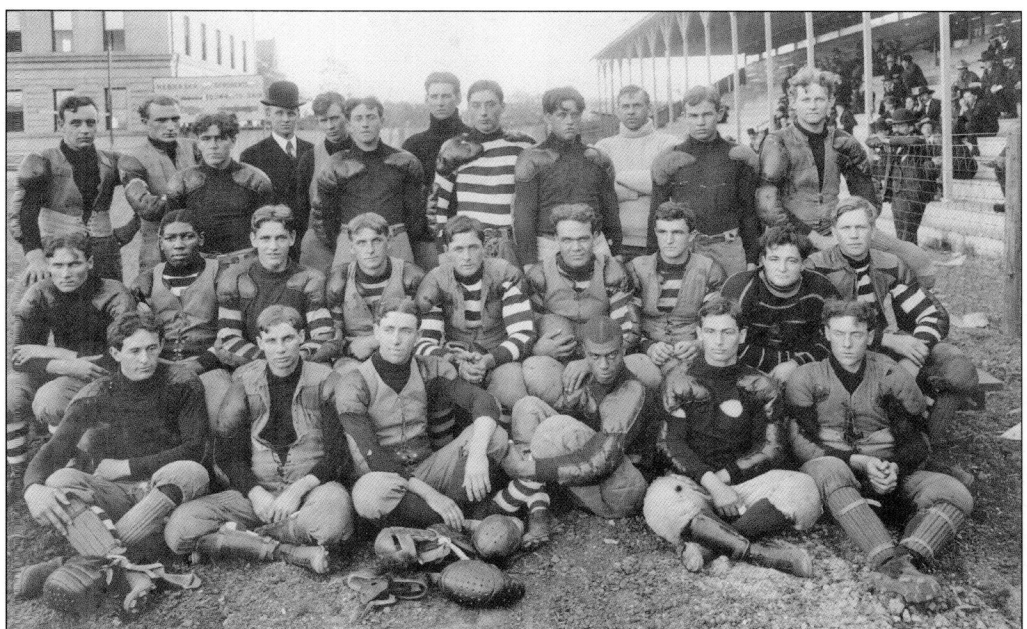

By the 1890s, football was the fastest growing sport on American campuses. Nebraska's first team played the Omaha YMCA in 1890; by 1893, the team had its first coach. Early names such as Tree Planters and Bugeaters didn't take, and when scarlet and cream were selected as the school colors, the sometimes-used Old Gold Knights was not suitable either. In 1900, local sports writer Cy Sherman suggested Cornhuskers, which gradually became the official name of Nebraska athletics. Coach W.C. "Bummy" Booth led the Cornhuskers to a 24-game winning streak between 1900 and 1905. In 1902, the Cornhuskers were unscored upon and undefeated. Above, the 1904 squad is pictured on the first field with newly constructed Brace Hall behind it, and below, Coach Booth (far left) is seen with members of the athletic committee in 1904.

DeWitt Bristol Brace was hired in 1889 to teach chemistry, physics, and electrical engineering. He began to develop the new department of physics upon his arrival. A true scholar, Brace had a doctorate from Berlin and had studied at Johns Hopkins. By 1900, his research in optics made him a leading national figure in his field. He is credited with illuminating the campus in the early 1890s.

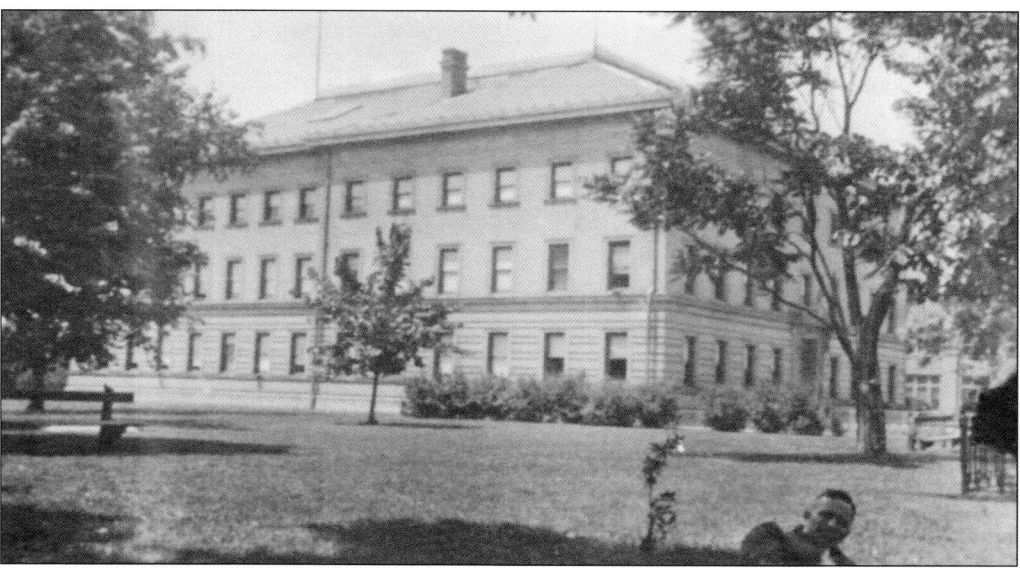

Brace lobbied for several years for a new laboratory for the growing physics department. He was successful in 1904, and work on a new building commenced. Shortly before the completion of the laboratory in 1905, he fell ill and died of septicemia at 46. His colleagues requested that the regents name the new building Brace Laboratory of Physics in his honor.

The Conservatory of Music was a private institution on R Street across from campus. Started in 1894 by Willard Kimball, it offered comprehensive musical instruction, which the university did not offer at that time. Students could matriculate at the conservatory or use music credits toward a university degree. The conservatory, later called the University School of Music, was purchased by the university in 1930.

In 1906, the university dedicated its first administration building, located on R Street west of the old chemistry laboratory. Designed by Omaha architect Thomas R. Kimball, the building had a covered entry on the R Street side. It housed all administrative offices, the registrar, the post office, and the *Daily Nebraskan* office. It was razed in 1963 after a new administration building was constructed in 1957.

Charles Russ Richards arrived at the university in 1892 to teach in the school of mechanical arts. Eventually he rose to become director of engineering programs and, ultimately, dean of engineering. Richards was instrumental in increasing enrollments in engineering, which at that time was the most popular program at the university. Richards left Nebraska in 1911 and eventually served as president of Lehigh University for many years.

In 1907, Richards asked to serve as architect for a new engineering laboratory building. He traveled to other universities to investigate engineering facility designs, and designed the Mechanical Engineering Laboratories to provide practical training space for engineering students. The building contained woodworking, foundry, drafting, and other laboratories and shops. It was renamed for Richards in 1944. It is now used for art studios, a gallery, and offices.

Three

MEANWHILE, AT THE FARM

The university's farm suffered an identity crisis during the earliest decades of its existence. Purchased but not financially supported, it initially served as a model farm, although not a very efficient model, and also as a test farm. A full-time manager was not hired until the 1880s and only after a losing battle to separate the land-grant college from the rest of the university was aired publicly. In 1889, S.W. Perin was hired to manage the farm, and Charles Bessey took an active interest in working with him to move the farm ahead. After 1900, the farm began to develop into an instructional campus.

The School of Agriculture, a finishing school of sorts for farmers, opened in 1895. Students were young farm boys with a minimum of eight years of school, which was the typical extent of a public education at that time. Their educations focused on practical farming and involved physical labor perhaps more than book learning. Wanting to create a synonymous program for girls, a program in domestic science was launched in 1906 with the opening of a new Women's Building, later called Home Economics. Both non-degree programs were highly successful until World War I. When public schools were expanded after the war, enrollment dropped, and the schools were discontinued in the 1920s.

As the School of Agriculture faded, the College of Agriculture flourished and soon became a leading agricultural research hub, with degree-granting programs in numerous related areas such as agricultural engineering, agricultural economics, and home economics, along with plant sciences, entomology, animal science, and horticulture. Experiment stations were developed throughout the state, and the extension service reached all counties. Eventually the campus gained its own student union, dormitories, a large freestanding library, and state-of-the-art research facilities. It was renamed East Campus in the 1960s.

The charter of the university clearly stated that a model farm was to be established as part of the College of Agriculture. When land originally selected north of campus along Salt Creek proved to be unsuitable, a farm belonging to Moses Culver was purchased in 1874. Two miles northeast of the campus, the farm had a small stone house and a frame structure. There was no instruction at the farm for two decades. Public transportation to the farm was unavailable, since it was located well beyond the city limits. For 15 years, the farm saw little improvement, but a farm manager was hired in 1889. This is an early photograph of the farm with the frame house (left) and stone house (center).

Senator W. "Will" Perin was hired as farm superintendent in 1889. Initially involved in farm work, Perin shortly began working with Charles Bessey and other faculty on research projects. After 1895, Perin and his wife, Laura, acted as parents in absentia to students in the School of Agriculture, many of whom boarded with the Perin family at the large frame home on the farm. Perin spent four decades supervising the farm and was fondly known to many as "Dad." He witnessed the transformation of the campus from a neglected farm to a busy teaching campus with multiple barns, academic buildings, and laboratories. The Porch is dedicated to the Perin family and is located at the original site of the frame house that served as Perin's home on campus. Perin is pictured near the present site of Agriculture Hall, with an Agriculture Extension building in the distance. (Nebraska State Historical Society.)

41

The 320-acre farm was two and a half miles from the downtown campus, and according to Charles Bessey, the trip to the farm was not easy, passing over dirt roads past fields, orchards, and unbroken prairie. The streetcar arrived at Twenty-Seventh and Holdrege Streets in 1903. Holdrege Street was unpaved and for many years was maintained by Will Perin. Shown here is Holdrege Street looking west prior to paving in 1912.

The School of Agriculture was created in 1895 as a farmer training school for boys who had completed eight grades, the full offering of Nebraska schools at that time. A domestic science program for girls was added in 1906. Neither program led to a college degree. Enrollment was high until 1918, when public schools expanded to 12 years. Students are pictured in front of the dairy barn in 1907.

In the 1890s, the farm campus was still undeveloped, with only one small instructional building. Bessey was instrumental in developing the Hatch Act, a national act that established agricultural experiment stations at land-grant institutions. He then used Hatch Act funds to construct the Agriculture Experiment Station building at the farm in 1899. The building still stands.

With the success of the School of Agriculture, the farm began to transition into a university campus. In 1904, construction began on Agricultural Hall, soon followed by the School of Domestic Science, later called Home Economics. Administrative offices, classrooms, and the library were housed in Agricultural Hall.

Class in Domestic Science – Kitchen Laboratory – University of N...

The School of Domestic Science, the forerunner of Home Economics, was developed by Prof. Rosa Bouton. A chemist and alumna, Bouton created and led the department from 1898 until 1912. Initially a nutrition class, domestic science was taught on the city campus in the mechanical arts building. The independent program grew rapidly, and in 1905, a new facility was constructed on the farm campus according to Bouton's specifications and contained kitchens and dormitory rooms for women students. The program was renamed Home Economics in 1906 and was later reorganized into the Industrial College and then the College of Agriculture. By 1912, the program had over 300 students. Here, young women prepare food in the old kitchen laboratory in the mechanical arts building in 1904.

As the agricultural campus grew, the mall served as its focal point. In 1909, regent George Coupland persuaded W.H. Dunman, an English landscape gardener, to join the staff at the university farm. Dunman established many woody and herbaceous planting beds that remain today. He retired in 1946, having devoted himself to the mall's beautification for 37 years. The mall is pictured in the 1920s with annual and perennial plantings.

The agricultural campus lay beyond the city limits in its early years and functioned primarily as an experimental farm and research station. After 1900, it became a teaching campus. The "farm," as it was called in the early years, was dotted with academic buildings and numerous barns for beef and dairy cattle. Barns disappeared as the campus grew eastward in the 1950s and 1960s. The farm is pictured looking north in the late 1920s.

During and after the Depression, extension forester Earl G. Maxwell planted many varieties of trees at the farm campus to test their suitability in Nebraska. Eventually, Maxwell planted over 100 varieties of trees on the east edge of campus. In 1969, the trial area was named Maxwell Arboretum in his honor. The arboretum is now home not only to trees but also to shrub collections, vines, and perennials and is used as a teaching collection as well as a park. Maxwell was a well-known campus character. A native of Indiana, he frequently quoted Hoosier poet James Whitcomb Riley in the many presentations he provided to community groups. Below, Maxwell works with youngsters on tree planting practices.

Four

PIONEERING WOMEN

Female professors were a rarity in higher education when the University of Nebraska opened for business in 1871. The first chancellor, Allan Benton, lobbied for a woman faculty member to assist with coeds, but not until 1877 did the regents approve the hiring of Ellen Smith. Chancellor MacLean posed a problem during his tenure in the 1890s when he resolutely refused to hire, and sometimes even retain, women faculty. His most shocking act was to remove the talented Mary Jones as head of the library, even in the face of glowing endorsements from faculty.

Coeds were particularly limited by their gender in the 19th century. The early Palladian Society was strictly male, as was the notorious Sem Bot. Women responded by creating their own societies, such as the coed Union literary society, which was formed as a result of the Palladian's all-male membership. Mariel Gere, daughter of regent Charles Gere, formed the Fem Bot Sem to protest her exclusion from the all-male Sem Bot.

Women earned a partial wage relative to their male counterparts and were often saddled with very heavy workloads; this was typical both nationally and at Nebraska. Regardless, the university was fortunate that so many talented women chose to devote their careers to teaching at Nebraska. Over time, their numbers grew and eventually included a few administrators.

For decades, women did not participate in intercollegiate athletic competition, although there was fierce competition between classes and sororities. The Women's Athletic Association promoted competition but was resolute in its rejection of varsity competition. Not until the passage of Title IX legislation in 1972 did women enter varsity athletics.

Women enrolled in increasing numbers, and by 1900 the university utilized a dean of women, a position that existed until 1971, when gender-based deanships were disappearing nationwide. Amanda Heppner, Eloise Piper, and Edna Barkley all served as deans of women and now have buildings bearing their names, as do Ellen Smith, Louise Pound, Mabel Lee, and Carrie Belle Raymond, influential faculty women who made their marks on the university through perseverance, dedication, and talent.

In 1877, Ellen Smith was the first woman instructor at the university. Hired to teach in the Latin school, she later became principal, then served as registrar and librarian. Known as "Ma" behind her back, Smith was feared and eventually beloved. Although several chancellors wanted to remove her, none were successful, and she remained a university employee until shortly before her death in 1903. Smith is seated at far left; Lawrence Bruner (left) and Charles Bessey stand behind her.

Chemist Rachel Lloyd was the second female faculty member at Nebraska, arriving in 1887. Widowed young, Lloyd earned a German doctorate in chemistry, likely the first American woman to do so. She studied sugar beets and promoted the beet industry in Nebraska. She was popular with students, but Chancellor Manatt questioned her piety and failed to renew her contract in 1888. The faculty unanimously voted to reinstate her.

Mary Jones graduated from Nebraska in 1885, then attended the nation's first library school, where she studied with Melvil Dewey. In 1892, Canfield hired her to become the first trained librarian at Nebraska. Faculty believed her work was meritorious. Sadly, when MacLean arrived, he announced that he would "secure a man librarian as soon as the University could pay a fitting salary." Jones resigned in 1897.

MAYSIE AMES. MARIEL GERE. ROSE HIGGINS. EDNA HYATT.
LOUISE LEE. ALTHEA ROBERTS. CORA SMITH.

Although women were eventually allowed to participate in the Sem Bot, initially they were excluded. Mariel Gere, daughter of regent Charles Gere, and other women studying science countered with their own botanical club in 1895, the Fem Bot Sem. After receiving her bachelor and master of arts degrees from Nebraska, Gere taught chemistry at Lincoln High School for 41 years.

Carrie Barbour was hired to teach art but quickly became interested in paleontology after visiting her brother Erwin Barbour at the museum. In 1892, she took coursework to increase her knowledge of paleontology, and eventually became the museum's assistant curator. Barbour participated in field expeditions and reconstructed fossil remains. She remained employed at the museum for 49 years. Pictured with museum staff, she is seated in the front row in an all-white dress, with Erwin Barbour at far right.

G. O. I.

Grand Premier,	Lulu M. Green.
Vice Premier,	Vesta Gray.
Custodian of the Mystic Sign,	Mary L. Fossler.

MEMBERS.

Lulu M. Green.	Flora Bullock.
Vesta Gray.	Emma Boose.
Mary L. Fossler.	Emma Grinstead.
Etta Gray.	Bertha Quaintance.
Christine Fossler.	Myra Babcock.
Anna Fossler.	Lincola Groat.
Stella Ducker.	Katherine Melick.
Elizabeth Field.	Stella Loughridge.
Donna A. Wilson.	Jessie Bigelow.
Fannie Byerly.	Myrtle Wheeler.

In the 19th century, young ladies were expected to have an escort when going to college-sponsored events or out in public. In the 1890s, a group of university women started an organization called GOI, or Go Out Independents. GOI women attended evening lectures, football games, and literary society events without escorts. These independent women had the full support of Chancellor Canfield. This is an image from the 1892 *Sombrero*.

Carrie Belle Raymond was hired by Canfield in 1894 to conduct the university chorus and orchestra. Soon, Raymond was also teaching sight reading at the University School of Music. Her interest in her students made the university chorus a success. She established the May Festival, directed an annual performance of the *Messiah*, and conducted operas and holiday concerts. Raymond died in 1927, still employed at the university. The first women's dormitory, Raymond Hall, was named for her in 1931. At right is Carrie Belle Raymond as a young woman, and below is a much older Raymond with the university chorus in April 1922. This photograph was taken in the art gallery when it was located in the first library. This room is now the architecture library reading room.

51

Willa Cather is perhaps the most acclaimed woman of her generation to study at Nebraska. Reared in Red Cloud, Cather entered the preparatory school in 1890, matriculated at the university in 1891, and graduated in 1895. While at Nebraska, she was managing editor of the student paper, the *Hesperian*, served as editor of the yearbook, and wrote theater reviews for the *Nebraska State Journal*. In Lincoln, she befriended the Gere sisters, the Canfield family, and especially Louise Pound. After college, Cather went to Pittsburgh and worked in publishing, then authored many novels and stories; several, such as *My Antonia*, were set in Nebraska. She won the Pulitzer Prize in 1923 for *One of Ours*. Cather retained ties to Nebraska and visited family in Red Cloud often. Cather Hall was named in her honor. She is pictured on the campus boulder during her student days at Nebraska in 1893. The pine tree still stands.

Louise Pound was a remarkable student from a respected Lincoln family. Her father, Stephen, was a judge, and brother Roscoe became a noted jurist. Louise excelled in many sports and was a champion tennis player, cyclist, and golfer. She earned bachelor's and master's degrees at Nebraska, in 1892 and 1895 respectively, then earned a doctorate from the University of Heidelberg in 1900. She returned to Lincoln and taught in the English department for 50 years. A nationally recognized linguist and folklorist, Pound was the first woman elected president of the Modern Language Association and was a charter member of the American Association of University Professors. A feminist and scholar, she was an advocate for women in sports and academics. Below is a tribute to Pound in the 1916 *Cornhusker*.

OUR FAVORITE

There is a professor named Pound
Who knows more than anyone round,
 Things she cant do,
 And succeed with it too,
Are not likely ever to be found.
 —*Contributed*

GIRL'S ATHLETIC SPONSOR

53

Mabel Lee arrived at Nebraska in 1924 to direct women's physical education, and retired in 1952 after attaining success both locally and at the national level. Lee promoted the health benefits of physical activity but was outspokenly opposed to varsity competition. This stance led to a bitter feud with Louise Pound, a fierce competitor. At 90, Lee attended the ceremony renaming the women's physical education building Mabel Lee Hall in 1977.

Although Ellen Smith was feared during her lifetime, she gained respect after her death. In 1920, the university purchased an elegant home on R Street and repurposed it as Ellen Smith Hall, the women's building. Installed within was the dean of women, at that time Amanda Heppner. The dean of women was expected to oversee coed activities and enforce rules applied to coed behavior. The interior of Ellen Smith Hall is pictured.

Basketball was a favorite with college women in the 1890s and 1900s. Sporadically managed by Louise Pound from 1901 to 1908, competitions were played against Lincoln High, the YWCA, and even Missouri. Later, inter-class competitions were held and involved fiercely competitive championships. This photograph was taken by Erwin Barbour in the 1890s south of Nebraska Hall. Houses can be seen on the east side of Twelfth Street.

Ina Gittings graduated in 1906 and became director of women's physical training at a time when women practiced behind closed doors. Gittings, a great athlete in her own right, expanded activities beyond basketball to include intramural hockey, gymnastics, and a track meet that broke the modesty barrier when it was held publicly at the athletic field. Gittings also sponsored the College Equal Suffrage League. She is seen here pole vaulting.

55

The women's track meet was an annual event introduced by Gittings in 1911. Since young women were usually not seen in public in athletic attire, men were not allowed to attend the first meets. Young men could not resist and went to great lengths to view the meets. In 1913, the track meet became public, and over 800 people paid to attend. The meet was held each May; crowds were entertained by the marching band, and the *Daily Nebraskan* sent reporters. Originally held at old Nebraska Field, it moved to Memorial Stadium in 1924. Above are hurdlers at the track meet; below is the team with bobbed hair and uncovered knees. Both pictures are from 1924.

Five

GROWTH AND CHANGE

Samuel Avery was named chancellor in 1909 after briefly serving as interim chancellor. During his nearly 20-year stint, the university more than doubled in size. The first five years of Avery's term were focused on the question of just how the university should expand. The colleges were reorganized in 1909, and the old Industrial College was eliminated, but little else was altered while the expansion dilemma was debated.

By 1910, the campus was out of space. To rectify this problem, many advocated for the removal of the downtown campus to the farm, which offered ample land upon which to expand. Avery, Charles Bessey, and several of the regents endorsed the removal, but the legislature failed to act. Later, a statewide referendum was set to decide the issue, but it was defeated. The legislature finally acknowledged that the university could not continue to do business without an improved physical plant and passed legislation that allowed for land acquisition and building funds. This led to expansion east to Fourteenth Street and north to Vine Street, more than tripling campus acreage.

World War I created upheaval on campus. A few faculty expressed doubts about the war, but Avery did not. He served as a major in the chemical warfare service in 1917–1918, and other faculty served as well. A disturbing series of loyalty trials tested faculty patriotism and targeted those who were perceived to be "not aggressively American." Twelve faculty faced a tribunal, and three lost their jobs.

Like most chancellors, Avery struggled with an inadequate budget. Poor salaries led to the loss of key faculty, and a plan to develop a Carnegie-sponsored retirement program was killed by the legislature at the urging of William Jennings Bryan. In 1923, tuition was charged for the first time. However, there were also happy events in the 1920s. Morrill Hall was constructed to house the remarkable fossil collections assembled by Erwin Barbour and held by the museum. The stadium and coliseum were constructed from donations. Enrollment continued to climb.

Samuel Avery received a bachelor's degree from Nebraska in 1892 and a doctorate from the University of Heidelberg in 1896. He then returned to Nebraska and became a professor of chemistry. Avery was named acting chancellor when Andrews resigned and became chancellor in 1909 after the regents failed to attract a national candidate. Avery led the university through the 1914 referendum that determined the future location of the university and the subsequent expansion of the downtown campus. He also led the university through the World War I years and served as an officer in the Army chemical warfare department. He was often viewed as a custodial chancellor rather than a visionary one by some faculty and others, although he was able to orchestrate considerable expansion of facilities during his term. He stepped down as chancellor in 1927 and returned to teaching in the chemistry department. Avery died in 1936; the second chemistry building was renamed Avery Hall in 1948.

Football had a firm grip on Nebraskans when Jumbo Stiehm was hired as coach in 1911. Stiehm coached at Nebraska for four seasons and remains the winningest coach in Cornhusker history with a 35-2-3 record. Nebraska's first All Americans were selected during his tenure: Vic Halligan and Guy Chamberlin. Stiehm left Nebraska when the university refused to meet his request for a salary increase to $4,250. From 1908 to 1923, football was played on Nebraska Field. Located at the site of Memorial Stadium, Nebraska Field was oriented east-to-west and seated at most 10,000 fans. Other great coaches, such as Bummy Booth, E.A. Bearg, and Fred Dawson, led competitions on Nebraska Field. In 1922, Dawson and the Cornhuskers, led by Ed Weir, beat Notre Dame and the Four Horsemen for the first time. Pictured at right is Guy Chamberlin, and below is Ed Weir.

Before 1926, graduation exercises were held in many locations, both on and off campus, and often included a processional with participants in academic attire. The 1910 commencement took place in the new Lincoln auditorium; participants gathered for this photograph prior to the processional. Pictured from left to right from the sundial are regents George Coupland, William Whitmore, and Charles Sumner Allen; Chancellor Avery; Deans Ellery Davis (arts and sciences), Charles Bessey (dean of deans), Charles Fordyce (teachers college), Lucius

60

Sherman (graduate college), Charles Richards (engineering), E.A. Burnett (agriculture), unidentified, William Hastings (law), and Robert Wolcott (medicine); and director of the University School of Music Willard Kimball. In the bowler hat behind Burnett is regent Frank Haller. Commencements moved to the newly constructed Coliseum in 1926.

Expanded City Campus

The First Layout
Featuring the Central Court and Gardens

Cornhusker, 1914

Prior to the November 1914 statewide referendum, Avery and the regents hired the nationally recognized Boston firm of Shepley, Rutan, and Coolidge to serve as official architects of the university. The firm developed plans for a potential consolidated campus at the farm, to be used if the consolidation bill was passed by voters. They also developed plans for an expanded city campus in case the bill was defeated. Plans were widely disseminated by the press. Ultimately the bill was defeated, and architects moved ahead with building plans for both campuses. In all, the firm designed seven buildings for the university and continued as official campus architects until 1925. It severed ties with the university after the stadium was built using local architects. At left is a plan for the extended city campus, and below is the consolidated farm campus plan.

Consolidated on the State Farm Site

The Second or "Diagonal Layout"

Cornhusker, 1914

Shepley, Rutan, and Coolidge were hired as official architects of the university in April 1914. The Boston firm described its proposed building designs as "collegiate." It utilized red brick and limestone on the downtown campus and buff brick and limestone on the farm campus. The firm gained fame for its work planning and designing Stanford University and the University of Chicago. Buildings on Nebraska's downtown campus included Bessey Hall, Chemistry Hall (Avery), Teachers College, and Social Sciences Hall; at the farm, the firm designed Filley Hall, the Animal Pathology complex, and Agricultural Engineering (Chase). Pictured above is Social Sciences Hall on the city campus. Below is Filley Hall, home to the Dairy Store at the agricultural campus.

The United States' entry into World War I in April 1917 quickly revolutionized campus life. Chancellor Avery joined the Army to serve in the chemical warfare service. The Reserve Officers Training Corps (ROTC) was introduced in 1917, and by 1918, the Students Army Training Corps moved into the still-unfinished Social Sciences Hall. Faculty who voiced concerns over the war and prevailing anti-German sentiment were accused of disloyalty. During the summer of 1918, several faculty members were subjected to loyalty trials, and a few lost their teaching positions. In all, over 2,300 students and faculty served in the war, and 44 were killed. Here, cadets conduct drill practice on Nebraska Field.

Memorial Stadium was built in 1923 to honor those who fought in World War I. Interest in a larger stadium was discussed before the war, and after, when other land-grant universities began to build stadiums to honor soldiers, Nebraska followed suit. The drive to build the stadium was spearheaded by the alumni association. It was funded through pledges made by students and citizens following an aggressive state- and campus-wide fundraising campaign. Local architects were hired to design the facility: Omaha firm John Latenser and Sons and Lincoln architect Ellery L. Davis, whose father was former dean of arts and sciences. The stadium was completed in six months, and the first game was played on October 13, a shutout against Oklahoma. The stadium was dedicated the following week, when Nebraska tied Kansas 0-0. This is the original architects' rendering of the stadium.

The success of the stadium led to financing for the Coliseum by borrowing against future gate receipts from football games to cover construction costs. Construction began in 1925. The Coliseum provided the first large indoor venue for sporting events, dances, and commencements. The board of regents contributed $100,000 to the project for the addition of a stage, making it suitable for dramatic productions and speakers. The Coliseum opened in time for spring 1926 commencement exercises. The Coliseum is seen above shortly after completion; below, an early basketball game is played in the newly completed facility.

This aerial view of the city campus taken in 1925 shows the newly completed stadium and Coliseum. The original campus, between Tenth and Twelfth Streets, is tightly packed with buildings. Social Sciences Hall, Teachers College, and Bessey Hall are visible east of Twelfth Street in the 1914 expansion area. The empty property at center right became home to Andrews Hall and later to Burnett Hall. The foundation of Morrill Hall can be seen in the same area, east of Bessey Hall. East of the Morrill Hall footprint is Bancroft School, eventually purchased from the school district to become part of campus. University Hall, in the center of the original campus, and Nebraska Hall, northeast of University Hall, appear without upper floors. The floors were removed from both buildings due to structural instability shortly before this photograph was taken. The columns located near the stadium were moved to the campus in 1930.

> Now no architect and no artist in all the long history of art and its development ever succeeded in creating a new form, nor will they in the future ever succeed in so doing. They have discovered the beauty of form and have adapted it to our uses and our tastes and our comfort. For instance, it has been said that a Greek workman some centuries before the beginning of the Christian era, carelessly placed a hollow tile cylinder upon the ground over a sprouting Acanthus plant and that in due time the plant grew up inside the tile and out of the top thereof and a builder passing by noted the beauty of the combination—the tile and the Acanthus plant growing out of it. This became the motif of the capitol of the Corinthian column that has been reproduced to this day in our most artistic structures.
>
> Again, we suppose that a gable roof is the simplest possible form of construction, the purpose of which is to keep the rain out of a building and the form was used by primitive builders for that purpose alone and without consciousness that it would one day be the form that should be used as a covering of the Parthenon, the most beautiful building of all times, nor that it would become the motif of the great Gothic cathedrals of the middle ages.
>
> Again, after the same method, there seems to be developing in this country of ours a new theme, or motif, in architecture that, like the others I have mentioned, seems to be the result of chance or

Regent George Seymour was elected in 1921 and developed an interest in campus planning. Working with Avery and others, he orchestrated plans in 1925 that incorporated expansions of both campuses. On the downtown campus, Seymour worked with the city to develop the "university zone," which determined R Street and Sixteenth Street as campus boundaries. Seymour also identified property for Greek Row and included two east-west malls, Memorial Mall and the Quadrangle. Greek fraternal societies were very active in the 1920s and were usually located in rented properties off-campus. Wishing to bring activities held at the Greek houses back to campus, Avery and Seymour worked with fraternities and sororities to develop sections of Sixteenth Street and along R Street for their houses. Houses were segregated by gender: sororities were located on the east side of Sixteenth Street, fraternities on the west side. R Street was strictly male. Most Greek houses were built between 1926 and 1930. This is the Seymour plan of 1925.

Andrews Hall opened for classes in September 1928. Named for the former chancellor, it housed not only the English and foreign language departments but also the Dental College. Located on the third floor, the college provided clinical space, classrooms, and laboratories. The Dental College remained in Andrews until a new facility opened on the east campus in 1968.

In June 1925, the legislature allocated $300,000 for the construction of a new museum to house natural history collections. Charles Morrill provided funds for the interior decorations, and interior murals were painted by Elizabeth Dolan. Ellery Davis served as architect; he went on to design many other campus buildings. The building was named Morrill Hall and dedicated in May 1927. Morrill attended the dedication and died the following year.

Registering for classes was an arduous task before the advent of computerized registration. Freshman registration took place at an appointed time and date, and students waited in long lines to sign up for classes. Here, freshmen students, divided by gender, wait in line to register outside of Grant Hall in 1923.

With students come cars. Increasing enrollment in the 1920s led to traffic and parking problems on the city campus. The intersection at Twelfth and R Streets reveals a chaotic scene, with pedestrians and automobiles competing for the right of way. Parking lots were not constructed on campus until after World War II. Here, looking north on Twelfth Street, the Chemistry Laboratory is on the left and Social Sciences Hall is at right.

Six

RITUALS, RITES, AND STUDENT FUN

Like students everywhere, the student body at Nebraska developed inventive ways to socialize. Regardless of the decade, there was never a shortage of clubs, events, and activities to bring young people into contact with one another.

During the first decades, literary societies met on Friday evenings and often included faculty. The Palladian, the oldest of the societies, initially did not allow women. Soon the Delian was formed so that women could also participate. These societies promoted scholarly and literary activities and were the main form of social interaction during the 19th century. Greek letter societies appeared in the 1880s, and by the turn of the 20th century had surpassed the literary societies' membership. Social activities focused less on lofty ideals and more on student interaction and fun. Sporting events became wildly popular, and by 1900, football was king. Women students no longer waited for male escorts and attended activities without them.

Ivy Day, a long-standing rite of spring sponsored by Innocents and Mortar Board, began in 1901 and became the culminating event of each academic year. More elaborate with each passing year, Ivy Day was a city-wide event.

After World War II, the Greek system dominated activities on campus. Formals were held throughout the winter, and no less than 10 queens were crowned, ranging from Cornhusker Beauty Queen to May Queen to Typical Nebraska Coed. The agricultural campus had its own series of events and crowned the Goddess of Agriculture and the Farmer's Formal Queen.

There were dozens of activities and organizations to distract and engage students. Class Olympics, the Women's Athletic Association, and Corncobs and Tassels, the men's and women's athletic cheering clubs, supported and engaged in athletics. Kosmet Klub and Coed Follies staged comedy productions every year. Nebraska Builders produced directories and acted as a student-led public relations firm. ROTC attracted large numbers of men.

As students changed, so did their activities. In the early 1960s, the band was limited to men. Women were expected to wear skirts and dresses. By the late 1960s, these rules were questioned, and other traditions were as well.

The earliest student organizations were the literary societies—the Palladian, the Adelphian, the Union, and the Delian. Meetings consisted of public speaking, lectures, music, and debates. They provided a social outlet for students who were otherwise restricted due to rigid societal limitations. Faculty often attended meetings and joined in the debates. The literary societies faded as Greek letter societies grew in popularity. Pictured is the Palladian room in University Hall.

In the early 20th century, at the urging of Charles Bessey, students held a mock trial each spring and condemned the yellow devil, otherwise known as the dandelion. Classes competed to rid the campus lawn of dandelions before Ivy Day and Commencement took place on the lawn. Their reward was ice cream. The event was discontinued by the 1920s. Dandelion diggers are pictured south of University Hall in 1911.

In 1891, the senior class gathered on the lawn to present its class gift of a large boulder to the university. In 1901, seniors began the ceremonial planting of ivy on University Hall, and by 1903, a Maypole dance was added. Gradually, the events of Ivy Day expanded to include all classes and many activities, including a pageant directed by Hartley Burr Alexander, singing competitions, oratory, inductions into Innocents and Black Masque, and reading of the class poems. Ivy Day continued in various iterations until students lost interest in the early 1970s. Here, students are planting ivy on the administration building in 1920 while May Pershing (center), the general's sister, looks on.

Over time, Ivy Day evolved into a day of great pageantry orchestrated by noted faculty member H.B. Alexander. The day included crowning of the May Queen, who was accompanied by an extensive royal court. As the pageant grew increasingly elaborate, it included young children who served as flower bearers, underclass women as junior attendants, and the May Queen and her attendants, dressed in white gowns. The Maypole dance was a regular feature at the early Ivy Day pageants, and dancers were usually underclass women. All Ivy Day events took place on the lawn at the center of the original campus. Above, 1936 May Queen Marion Smith is pictured with her court. Below are Maypole dancers in 1920.

The Innocents Society was founded in 1903 as a senior honorary society for men. Suggested by Roscoe Pound and sponsored by Prof. George Condra to recognize leadership, character, and service, the group donned hooded red robes for special occasions and rituals. Thirteen men were tapped each spring at Ivy Day, and thus the society was self-perpetuating.

In 1905, the Black Masque honorary society was formed as the women's counterpart to the Innocents. Like the Innocents, the Black Masque selected 13 new members at Ivy Day, but women wore masks instead of hoods. In 1921, the society aligned itself with the national honorary Mortar Board and became the Black Masque chapter.

In 1894, Lt. John Pershing selected a group of cadets to compete as a drill team at the national competitive drills held in Omaha. The company won the competition, $1,500, and the Maiden Cup. That fall, the same cadets formed the Varsity Rifles, led by Pershing. Pershing was reassigned by the Army in May 1895; the Varsity Rifles renamed themselves the Pershing Rifles in his honor after his departure. In 1928, the Pershing Rifles became a national organization. Military training had been unpopular with students until Pershing's arrival. Cadets are pictured in 1894 in formation on the west side of University Hall with Grant Hall in the background.

The earliest student publication, the *Monthly Hesperian*, was a newspaper and literary magazine. It merged with its rival publication at the farm campus, the *Nebraskan*, to become the *Daily Nebraskan* in 1901. Also produced at the farm was the *Cornhusker Countryman*, published sporadically from 1921 to 1952. *Awgwan*, a humor publication written by the journalism honorary society, was produced erratically from 1913 to 1946. The first yearbook, the *Sombrero*, evolved into the *Cornhusker* in 1907 after athletic teams had settled on that name. In 1912, Samuel Avery formed the Student Publications Board, primarily composed of faculty, to oversee student publications. The *Cornhusker* was discontinued after 1972, with a brief revival from 1999 to 2001. Above is the *Awgwan* staff in the 1920s, and at right is the frontispiece from the 1919 *Cornhusker*.

The annual Farmer's Fair was held beginning in 1916 to promote and celebrate the College of Agriculture. By the 1920s, it consisted of a large parade on O Street led by the Goddess of Agriculture, a home economics student. The campus hosted exhibits, horse shows, and a pageant. Classes were dismissed for two days to prepare for this major event. The Farmer's Fair continued until 1959. Above, the 1922 Goddess of Agriculture rides on a float, and below is the 1924 Farmers Fair near Chase Hall.

In 1909, Charles Bessey and Prof. George Condra started the Class Olympics to more properly channel the interclass rivalry that existed between freshmen and sophomores. A popular event for several decades, the Olympics eliminated the bloody fistfights that previously took place. Here, in 1922, students battle for control of a giant ball while alumni watch. In the distance are old Nebraska Hall and the new Chemistry Laboratory.

Popular professor Miller Moore Fogg established a debate team shortly after arriving from Harvard in 1901. By the 1910s, debate had become one of the most popular activities on campus. Fogg developed the highly successful Nebraska System for coaching debate, and men on the team participated in his "think shop." When Fogg died suddenly in 1926, classes were cancelled for his funeral. Pictured are Fogg and the debate team in 1920.

The custom of class gifts began in 1891 with a large boulder placed on the south lawn. This event also marked the beginning of Ivy Day celebrations. Other class gifts soon followed. In the early 20th century, a sundial, a large stone drinking fountain, and the clock above the library entrance were gifts from graduating classes, the latter in 1912. Perhaps the most visible gift today is the curved stone bench east of the old library, which was given by the class of 1906. Students on the agricultural campus also made gifts to the institution, including a map of the campus on a bronze tablet from the class of 1914. Above, around 1910, coeds are seated on the boulder near the fountain and sundial. At left, Fount Davisson, named for the principal of the School of Agriculture, was a gift from the class of 1911.

Seven

DARK DAYS

The Great Depression and World War II years were difficult for Chancellor Burnett and the university. Faculty saw their pay reduced by 10 percent in 1932 and by 22 percent in 1934. The state's financial support to the university shrank because of diminished revenues. New buildings went unbuilt, and existing buildings were not maintained. University Hall and Nebraska Hall remained, but their upper floors were removed due to structural instability. By the outbreak of World War II, the campus was run down. The bright spot was the opening of the Student Union in 1938.

Yet student life continued as usual. The Ivy Day pageant was more elegant than ever. The *Cornhusker* yearbook and the *Daily Nebraskan* continued publishing, and students carried on with their activities and classes. Football continued to be a campus- and statewide obsession, and Dana X. Bible won six conference titles in his eight years as coach.

However, student attrition was high, and many freshmen didn't return for their sophomore year. Classes were too large and faculty stretched too thin. The idea of limiting enrollment surfaced as a way of dealing with these problems, but it was too controversial.

For many years, the problem of a faculty retirement program had been discussed but not resolved. Faculty often worked well beyond 70, and even 80, since they had no means of supporting themselves in retirement. Regents tried to devise a retirement system, but it was insufficient. When the new chancellor, Chauncey Boucher, arrived on campus in 1938, he made matters even worse by reducing the meager stipends provided by the regents. It was 30 years before the retirement situation was successfully addressed.

The war changed campus. It took young men away before they graduated and brought others to campus as soldier trainees. The Student Union became a mess hall. Remaining students lived with rationing; house parties replaced formals, and Cokes and cigarettes were in short supply. Students formed the War Council and led scrap metal drives, sold war stamps, and volunteered for the Red Cross. The military ball was the social event each winter.

Edgar Burnett was hired by Charles Bessey in 1899 to direct work in animal husbandry. He soon took over the Agricultural Experimental Station and served as Bessey's assistant dean in the old Industrial College. In 1908, when the Industrial College was split into engineering and agriculture, Burnett became dean of agriculture. Burnett's early career was tied to the agricultural campus, where he found success. In 1927, he was named acting chancellor, and he became chancellor in 1928. Success as chancellor was more elusive. Burnett took charge just before the Great Depression forced the university into a holding pattern that lasted over a decade. Unable to secure adequate funding during the worst years of the Depression, Burnett began promoting the idea of a foundation that would act as a fundraising entity for the university. Burnett retired in 1938, having held the university together during the worst of the Depression. He died in 1941. Burnett Hall was named in his honor in 1946.

Burnett established the University Foundation in 1936, following the pattern of other major universities. He understood that the state's limited resources could never fully meet the needs of the growing university. Following retirement in 1938, Burnett continued to work with the foundation. His friendship with Don Love resulted in gifts that financed two dormitories and a library. At right, Love (left) and Burnett lay the cornerstone for Julia Love Memorial Hall.

Burnett secured partial funding from the state for the first new dormitory at the university, a women's facility named Raymond Hall. He created the University Dormitory Corporation to partially finance it and future dormitories using bonds. The elegant Raymond Hall opened in 1932 and was later expanded to include Love, Heppner, and Piper Halls. The entire complex was renamed the John G. Neihardt Residential Center in 1973.

Building the Student Union marked a high point in student leadership. After years of lobbying for a union, student leaders partnered with the alumni association and in 1936 convinced the conservative board of regents to request Public Works Administration funds to supplement their own fundraising efforts. The completed and beautifully appointed union opened in May 1938 to great fanfare. Pictured is the Student Union on R Street, with Ellen Smith Hall on the left.

Chauncey Boucher arrived in 1938 to become chancellor, the first external leader since Andrews's retirement in 1908. A historian, he was an educational reformer and innovator but also aloof and elitist and did not advocate for faculty. In fact, his budget requests to the legislature were smaller than several previous budgets, and faculty were irate. The university was crowded and in disrepair, and the faculty had taken a series of pay cuts. Boucher then revamped an inadequate retirement program, making it even worse. Eventually Boucher strengthened some academic areas. However, faculty, angered by his lack of empathy, approached the legislature directly and found some financial relief. After years of conflict, Boucher retired due to poor health in 1946.

Former mayor Don L. Love was a successful Lincoln businessman with interests in banking and insurance. A friend of Edgar Burnett's, he made several large gifts to the university, including two dormitories named in his wife, Julia's, honor. Through the university foundation, Love donated $850,000 for construction of a new library to become available after his death, which occurred in 1940.

The Love Library cornerstone-laying ceremony occurred on December 12, 1941. Pictured at the ceremony are R.A. Miller (second from left), director of libraries, and regent Robert Devoe (with trowel). On the right of the cornerstone, from left to right, are T.R. Thompson, dean of men; Lawrence Seaton, director of facilities; Chancellor Boucher; William Burr, dean of agriculture; and Charles Oldfather, dean of arts and sciences.

The cornerstone of Love Library was laid in December 1941, days after the Pearl Harbor bombing. Desperately needed for growing library collections and students, its construction was interrupted by war. In 1943, it was converted into barracks for the Army Specialized Training (AST) program before construction was completed. The Army used the unfinished building for over a year. Here, AST student cadets play ping pong in the current Love South second-floor reading room.

Nisei, Americans of Japanese descent, could enroll at Nebraska during World War II when other universities forbade their admission. Most arrived from internment camps. When the Nisei enlistment ban was lifted in March 1944, many enlisted in the military. Ben Kuroki (pictured) flew 58 missions, was awarded three Distinguished Flying Crosses, and later received a bachelor's in journalism and an honorary doctorate from Nebraska.

In 1927, the art gallery moved from the upper level of the old library to Morrill Hall, where it remained for over 30 years. Dwight Kirsch served as an art professor and gallery director from 1924 until his departure for the Des Moines Art Center in 1950. Kirsch was instrumental in building the museum's contemporary collections. He is pictured with a student in the 1940s.

Eight

BECOMING A RESEARCH UNIVERSITY

The two decades that followed World War II were some of the most challenging and exciting in the university's history. Growth was unprecedented as soldiers returned to pursue their educations. Enrollment in 1946–1948 was nearly unmanageable as new chancellor Rueben Gustavson struggled to provide classrooms, academic counseling, veterans' programs, and medical care for nearly 10,000 students, twice the number that had been on campus during the war. Housing for male students was very limited on campus, and air base housing was converted into married student housing and renamed "Huskerville."

Postwar budgets improved, and facilities were updated during the 1950s as part of a 10-year building program. Dormitories were constructed, the Student Union was expanded, and Burnett Hall, planned in 1928, was finally finished. Faculty became more research-oriented to capitalize on federal dollars directed at strengthening American science and industry. Clifford Hardin arrived in 1954 to become chancellor. For students, old traditions returned and new traditions were introduced. The notorious panty raid turned riot of 1955 was an indicator that American youth were restless, however, as the following decade would prove.

The 1960s began quietly enough, but as the decade progressed, issues such as the war in Vietnam, civil and women's rights, and shifts in youth culture were heard and felt on campus. Another building program provided much-needed revenue to meet the demands of a growing enrollment. Appropriations for instruction, laboratories, faculty offices, new dormitories, and property expansion occurred during the 1960s.

In 1966, the legislature and the municipal Omaha University pushed the university in Lincoln to consider forming a new system that would merge the two institutions. By 1967, a bargain had been made. Faculty on both campuses were wary, and the reorganization required a level of cooperation that was hard to attain. Chancellor Hardin, who led the university in Lincoln for 15 years, was appointed to lead the new system. But Hardin departed to become the US secretary of agriculture in late 1968, just six months after the reorganization became effective. With his departure, life on campus became even more unsettled and interesting.

In 1946, Reuben Gustavson became the 10th chancellor of the university. Large, friendly, liberal, and scholarly, "Gus" brought fresh ideas and forward momentum to campus after two decades of depression, war, and stagnation. He fostered a culture of faculty governance and led institutional efforts to increase research and capitalize on federal initiatives. He also worked with the University Foundation to develop a culture of charitable giving to the university. Gustavson worked to integrate student housing and fought to deflect claims that the university was a hotbed of communist sympathizers. Popular with both faculty and students, Gustavson resigned in 1953.

Twelfth and R Streets were a hub of activity during the first week of school in September 1946. The intersection was famously unsafe for pedestrians. Twelfth Street was a through street until the mid-1960s, when it was closed to create a pedestrian mall. Pictured is the intersection looking east; Social Sciences Hall and the newly opened Love Library are at left.

As veterans returned to civilian life, many elected to use the GI Bill to pursue their educations. Enrollment doubled, from under 5,000 to over 9,000, between 1945 and 1946. Administrators struggled to provide space and services for veterans, and new construction stalled due to steel and brick shortages. Here, temporary buildings are erected on the quadrangle. Burnett Hall is under construction in the distance.

Love Library was finally dedicated in October 1947, six years after the ground-breaking ceremony. The new building consolidated books and materials stashed in 23 locations around campus. Love utilized a modern arrangement with subject-specific reading rooms, including humanities, social sciences, education, and science. It also had private rooms for faculty and graduate student researchers. Although the library opened in late 1945, many rooms remained unfurnished, and finishes were not complete for over a year due to postwar shortages. Above is the original north facade of the library, and below is the humanities reading room on the second floor.

This 1953 photograph was taken from the Love cupola looking east. In the distance at left are Seaton, Fairfield, and Benton Halls, the first men's dormitories. In the center are commercial buildings, including popular Uni Drug, and boardinghouses, all removed to build Selleck Quadrangle and parking lots shortly after this was taken. In the far distance at right is the cupola on the women's residence hall, Raymond Hall, and Whittier School (center).

The Crib, located in the Student Union, was a popular hangout where students played the jukebox, smoked cigarettes, and enjoyed Cokes and snacks. The walls featured murals of campus scenes and activities. Students are pictured here in the Crib in 1949.

Clifford Hardin served as chancellor for 15 years beginning in 1954. The Hardin era began during a time of student conformity but ended during an era of campus unrest. Hardin oversaw the adoption of the municipal Omaha University, resulting in the creation of the University of Nebraska system, which he administered. Hardin resigned in late 1968 to become US secretary of agriculture in the Nixon administration. Pictured below is the chancellor's conference room in the 1957 administration building. Pictured with Hardin (far left) in 1965 are, from left to right, vice chancellors Joseph Soshnick, Adam Breckenridge, Merk Hobson, and unidentified.

Ralph Mueller, an 1898 graduate in electrical engineering, became a benefactor to the university after inventing and manufacturing the ubiquitous alligator clip through his own company, Mueller Electric Company. In 1949, at Gustavson's request, he provided funds for Mueller Tower, which incorporated electronic hammers. The tower was designed following a competition among architecture students, and George Kuska's entry was selected. Students were instructed to integrate corn into their designs. Later, Gustavson asked Mueller to provide funds for a planetarium. The Mueller Planetarium was added to Morrill Hall and opened in 1957. Above, Mueller Tower (left) has a corn motif around the upper edge. At right, Chancellor Hardin presents an award to Mueller in 1956.

Built in 1888 on the original campus, the first Nebraska Hall was crumbling years before its demolition in 1962; its upper floor was removed in 1925 to make it safe for use. In 1958, the university purchased the former Elgin watch factory on the recently acquired property northeast of the campus. In the 1960s, engineering programs were gradually moved from their original buildings to what became the second Nebraska Hall. At left, Hardin is pictured at the 1962 demolition of old Nebraska Hall with the cornerstone that held Charles Bessey's motto, "Science with Practice." Below, a photograph taken from the roof of the second Nebraska Hall shows new dormitories Abel and Sandoz Halls being constructed in the distance in 1966.

When veterans arrived on campus following the war, most drove a car. Parking, a problem for decades, became nearly impossible. When student veterans confronted ticketing police, the police responded with teargas. Cooler heads prevailed, and veterans then marched around campus and paraded in their cars on O street. The incident was humorously known as the "parking riot" of 1948.

In 1950, Norman Geske began working for the university art gallery when it was located in Morrill Hall. He became director of the gallery in 1956 and began planning a new building to be constructed with funds from the Sheldon family. Geske oversaw the move of collections into the new gallery in 1963, later establishing the nation's third sculpture garden in 1970. This is the old gallery in Morrill Hall in 1954.

John William "Johnny" Carson performed comedy and magic shows and acted as master of ceremonies for campus events while attending the university following service in the Navy during World War II. Carson majored in speech and drama, receiving his degree in 1949. He went on to a successful career as popular host of the *Tonight Show* from 1962 to 1992. The Johnny Carson School of Theater and Film is named in his honor. This is an early publicity photograph of Carson.

From its earliest years, the university supported a preparatory school, eventually becoming a practice school for teacher training. Originally it was housed in the Temple, then after 1920 in the old Teachers College building. A new facility was opened as University High in 1955 with space for many additional activities, such as shop and home economics. University High closed in 1967 and was renamed Henzlik Hall.

The Nebraska Union underwent the first of three expansions in the late 1950s. Twenty years after its first dedication, a north addition was opened with enlarged lounges and meeting rooms designed to meet the needs of a larger campus population. The addition was funded with a $5 increase in tuition, raising costs to $90 per semester for Nebraska residents. Seen above are ground-breaking ceremonies for the 1957 addition. The original north facade of the union is visible. Below is the 1957 addition with a drive-up entry, removed in a 1968 addition and renovation.

Although the custom of freshmen wearing beanies was not unique to Nebraska, it was a long-standing practice that began at the university in the 1920s, when freshmen wore green beanies through their first semester. By the 1940s, beanies were red and white. At left, freshmen purchase beanies adorned with graduation years at local department store Ben Simons in 1956.

The *Prairie Schooner* literary magazine was founded in 1927 by popular English professor Lowry Wimberly. Later editors included Pulitzer-winning poet Karl Shapiro and noted Cather scholar Bernice Slote. The magazine remains one of the longest-running literary magazines in the United States. From left to right are Shapiro, Slote, and James Miller Jr., chair of English in 1960.

100

Nebraska poet laureate John G. Neihardt and author Mari Sandoz frequently visited Lincoln and spoke to university students and faculty. Both were recipients of honorary doctorates, Neihardt in 1917 and Sandoz in 1950. From left to right in 1962 are (first row) Neihardt, Sandoz, and Gov. Frank Morrison; (second row) unidentified and Chancellor Hardin.

Future chancellor Harvey Perlman attended the university, receiving his bachelor's degree in history in 1963 and his juris doctorate in 1966. Perlman went on to serve as a law professor, dean of law, acting vice chancellor, and ultimately chancellor in 2000. At left, undergraduate Perlman poses as president of his fraternity, Sigma Alpha Mu, in 1962.

Nebraska Republicans and university Young Republicans sponsored a campus visit by Arizona senator Barry Goldwater in April 1962. Author of *The Conscience of a Conservative* (1960), Goldwater drew 6,000 students to his presentation at the Coliseum. He declared that he had no interest in the 1964 Republican presidential nomination, stating "I am not looking for it and I do not intend to." Goldwater was on the Republican ballot in 1964.

Downtown Lincoln and the university campus have had a symbiotic relationship for decades. This photograph, taken around 1950, shows the corner of Thirteenth and R Streets looking south. Boardinghouses, a bookstore, and Tastee Inn (white building) are seen on the site of the current Van Brunt Visitors Center. The large building at Thirteenth and Q Streets housed the Western Electric plant.

Hired in 1962, football coach Bob Devaney engineered a return to greatness for the once-proud Nebraska Cornhuskers. Devaney served as head coach from 1962 to 1972 and won two national championships. He coached a 32-game winning streak before stepping down to serve as athletic director. His record at Nebraska was 101-20-2, unmatched at that time. Funny and popular, Devaney was inducted into the College Football Hall of Fame in 1981.

C.Y. Thompson Library was dedicated on January 8, 1966. The much-needed facility consolidated materials formerly housed in the old Agricultural Hall library and scattered storage areas. The library was named to honor C.Y. Thompson, a lawyer and farmer from West Point who served on the board of regents for 24 years and was an influential member of the agricultural community in Nebraska.

Philip Johnson, architect of Sheldon Art Gallery, attended and spoke at dedication events on May 16, 1963. Construction of the landmark building was made possible by a gift from Mary Frances Sheldon and her brother A. Bromley Sheldon. The building was renamed Sheldon Museum of Art in 2008, and in 2013, when the building was in its 50th year, it was listed in the National Register of Historic Places. Above, at the building dedication with sculpture *Princess X* by Constantin Brancusi, are, from left to right, Martha Hardin; Norman Geske; Chancellor Hardin; Olga Sheldon, widow of donor Bromley Sheldon; and architect Philip Johnson. At left, Norman Geske is interviewed in the great hall of the gallery in 1963.

Sheldon Art Gallery opened in 1963, and a few years later, Twelfth Street was closed to create a pedestrian mall. In 1970, the sculpture garden and fountains were created on the west side of the museum; eventually, gallery sculptures spread across campus. Sheldon Art Gallery is pictured with its sculpture garden and artworks.

Over 2,500 students gathered on the lawn west of Sheldon Art Gallery in September 1964 for jazz festival performances, including one by the Stan Getz Quintet and Astrud Gilberto. Getz and Gilberto were riding a wave of popularity with their mega-hit "The Girl from Ipanema." In 1991, this site became the home of Jazz in June, a popular annual series.

Commencement exercises were held in many locations, both on and off campus, before the completion of the Devaney Center in 1976. The Coliseum was mainly used during the 1940s and 1950s, but as the number of graduates increased in the 1960s, Pershing Auditorium was rented, and there were two commencement ceremonies on the same day. By the early 1970s, it was nearly impossible to accommodate all graduates. Summer commencement became regularized following the war; in the early 1960s, Memorial Mall was the site of summer exercises, held in the evening. Above is the processional south from the Coliseum, and below, commencement participants are seated on Memorial Mall in August 1962.

The firm of Caudill, Rowlett, and Scott was hired as the campus planner in 1966 and recommended street closings to assure pedestrian safety and to create a "pedestrium." In early 1968, Fourteenth Street was closed between R and Vine Streets. Twelfth Street was closed from R Street to the stadium. Pedestrians and vehicles are pictured on Fourteenth Street near the Student Union in the early 1960s.

In the 1960s, student enrollment rose very rapidly. In 1963, the university responded by quickly building two high-rise dormitories named Cather and Pound, and two more followed in 1964, Abel and Sandoz. Construction on three additional high-rise dormitories was started in 1966. Enrollment passed 10,000 in 1963; by 1969, it was almost 20,000. From left to right are Smith, Schramm, and Harper Halls.

In 1957, Duke Ellington and his orchestra provided the music for the homecoming dance. The 1950s and 1960s saw many well-known musicians perform courtesy of the Union Program Council. Others included Tommy Dorsey, Simon and Garfunkel, the Supremes, the Smothers Brothers, Joan Baez, Peter, Paul, and Mary, and various jazz artists such as Stan Getz. Above, students talk with Ellington at the Coliseum.

In March 1968, Bobby Kennedy made a last-minute campaign stop in Lincoln and spoke to 12,000 students. Kennedy had announced his presidential candidacy just days earlier. His speech emphasized peace and offered alternatives to the country's involvement in the Vietnam War. Three months later, Kennedy was gunned down in Los Angeles hours after winning the California primary.

Nine

BUILDING A SYSTEM

The late 1960s and early 1970s were challenging times for the nation and its universities. Young people were restless, and the political landscape, with an unpopular war and civil unrest, infiltrated the national psyche. For leaders at large public universities, this period was probably more difficult to manage than any other. At Nebraska, this was certainly true.

When Clifford Hardin resigned in late 1968, the University of Nebraska system was newly formed, and faculty remained uncertain about the arrangement with Omaha. The board of regents elected to hire a system president, Durward Varner. Varner's task was to build an integrated multi-campus university system and serve as top administrator for the new organization. It was a challenging job.

As the university administration worked to resolve merger issues, students and faculty were unsettled and angry. African American students were angered at under-representation, and many students were angered at the parental role the university often assumed. Antiwar sentiment was increasing, not only among young people but also among faculty. Nationally, campuses witnessed violent protests. Joseph Soshnick briefly served as chancellor of the Lincoln campus but resigned in 1971. Two more chancellors were hired before the 1970s ended.

Martin Massengale served as chancellor from 1981 to 1991, and for the first time in decades, enrollment flattened as a result of changing demographics. Massengale became system president in 1991, and the chancellorship on the Lincoln campus again changed hands twice before the decade ended.

In 2000, Harvey Perlman, dean of the College of Law, became acting chancellor. He became chancellor a year later. During his term, the university experienced an unprecedented building boom. He successfully led efforts to annex the former state fair grounds for the development of Innovation Campus. Perlman also was instrumental in leading the university's move to the Big 10 academic and athletic conference. Perlman served as chancellor for 16 years, resigning in 2016. In May 2016, Dr. Ronnie Green became the 20th chancellor of the University of Nebraska.

On July 1, 1968, the University of Nebraska and Omaha University joined to become one university system, along with the College of Medicine. The merger was a quickly devised scheme designed to salvage the financially broken municipal university in Omaha. Not without controversy, the legislature approved the new system as part of a statewide tax reform deal. Clifford Hardin was appointed to lead the new system while also serving as leader of the Lincoln campus. At the end of the year, he left to become US secretary of agriculture. In 1971, the regents formed a centralized administration as an additional administrative layer. Each of the three campuses had a chancellor, and the system was run by a president. Above, merger ceremonies take place at the Omaha campus with Hardin at the podium and Omaha chancellor Kirk Naylor (standing, second from left) and Gov. Norbert Tiemann (third from left) standing behind him. (University of Nebraska at Omaha Archives and Special Collections.)

With Hardin's departure as head of both the Lincoln campus and the newly created system, a replacement was found in Durward "Woody" Varner. Varner was the first to hold the title of president of the university system. After seven years, Varner resigned and joined the University of Nebraska Foundation, where his engaging personality made him highly successful. The central administration building was renamed Varner Hall in 1985.

In 1969, Joseph Soshnick became chancellor when Hardin took leave to join Nixon's cabinet. Soshnick served as vice chancellor under Hardin and agreed to serve as his stand-in while Hardin went to Washington. Six months later, the arrangement became permanent. Soshnick was a friend to students. He negotiated the student takeover of the military science building without violence; instead, he sent them doughnuts. He resigned unexpectedly in 1971.

Oldfather Hall was dedicated in October 1969, nearly a year after opening. The building was the first skyscraper to fill the campus skyline and was named for long-time dean of arts and sciences Charles Oldfather. Hamilton Hall, the second skyscraper, opened in 1970 and was named for former chemistry department chair Cliff Hamilton. This aerial view shows Hamilton, left, and Oldfather, upper right, on a football Saturday in the early 1970s.

In the 1960s, Nebraska women students questioned the limits placed on their lives by dormitory rules that did not apply to males. The Association of Women Students, created in 1911, had served as a self-policing body for decades, dictating curfews and meting out punishments. Female students voted it out of existence in 1970, and a long debate with administration ensued regarding dormitory hours. At right are coeds in Raymond Hall in 1957.

In 1967, Nebraska celebrated its centennial with hundreds of statewide and local events. Broadcast journalism students produced a day-to-day centennial news report on historical events in 1867. They received an Ak-Sar-Ben public service award for their work. Nebraska governor Norbert Tiemann was a strong supporter of the university and facilitated significant improvements in university funding. Here, Tiemann issues a statehood proclamation along with Chancellor Hardin and members of the university's journalism school. From left to right are Tiemann, Emily Trickey, Hardin, and Neale Copple, director of the School of Journalism, in March 1967.

As the university's centennial approached, there was great interest in commemorating the event on campus. An innovative program of education, the Centennial Education Program, opened in the fall of 1969. Centennial was an interdisciplinary living-learning experience, where students and faculty, who were called fellows, worked collaboratively on courses of mutual interest. The Love and Heppner dormitories were designated for program use, and faculty offices were located on site. Robert Knoll spearheaded the creation of the program and served as an early fellow. Above, Knoll, second from right, is pictured with students in a typically informal discussion. Below is a hand-painted Centennial College sign with bicycles.

In 1969, the Afro-American Collegiate Society was formed to address issues of underrepresentation of blacks on campus. In April, they staged a three-day protest at the administration building and presented a list of 12 demands to administrators. Demands included more aggressive recruitment of black students and faculty, the hiring of a minority affairs coordinator, and courses in black literature, culture, and history.

In 1972, Chancellor James Zumberge announced that the university had identified a small, unused building on North Sixteenth Street to become a cultural center. The center was included in demands presented to university administrators by black students during their 1969 protest. Programming was offered by the relatively new minority affairs coordinator. Pictured at right are students and administrators at the cultural center as it undergoes improvements in 1974.

115

Interest in football surged in the 1960s after the arrival and success of coach Bob Devaney. It reached a fever pitch when the Cornhuskers won the first of five national championships in 1970 and repeated in 1971. Pres. Richard Nixon congratulated the team and coaches as thousands watched at the Coliseum in January 1971. Nixon is pictured with team captains hoisting the championship plaque.

As enrollment climbed in the 1960s, long lines became a fact of life. Students routinely queued up to register, drop or add courses, purchase parking permits and football tickets, and buy books. Most of these functions were computerized in the 1990s and 2000s. Here, students line up at the administration building for late registration in September 1969.

American students protested the expansion of the Vietnam War into Cambodia, and on May 4, 1970, four students at Kent State University were shot to death during protests. Students at Nebraska took over the military science building and ultimately called to join the national student strike. Chancellor Soshnick and administrators met with students to hear their demands. Many students remained until the next day, when they left to meet with the university senate. Nationally, over four million students participated in the strike, and public opposition to the war escalated. In September, when Army chief of staff Gen. William Westmoreland came to Lincoln to speak, students staged a protest march through campus and downtown Lincoln. At right, the *Daily Nebraskan* reports on the strike, which faculty supported, and below, students protest at the Cornhusker Hotel, where Westmoreland was speaking.

University administration was unstable in the 1970s. An added layer of administration was created when the regents hired Woody Varner as president of the new university system. After the 1971 resignation of Joseph Soshnick, the regents hired James Zumberge (left) as chancellor of the Lincoln campus. By mid-1975, he was gone. In 1976, Roy Young (below) arrived; he stayed less than four years. Varner resigned and was replaced by Ronald Roskens in 1977. Both Zumberge and Young were hampered by inadequate resources, poor faculty salaries, and difficult regents. Their work was complicated by student demands. Faculty grew tired of low wages and nearly voted to unionize as their counterparts in Omaha had done.

Johnny Carson returned to campus to celebrate homecoming while the Cornhuskers were riding an even higher wave of popularity between the 1970 and 1971 championships. He is pictured here during homecoming festivities with cheerleaders in October 1971. Nebraska shut out the Kansas Jayhawks 55-0. The homecoming theme was "Make Love Number 1" to raise funds for the library.

By 1969, Love Library was no longer a spacious new facility. Furnishings were worn, lighting was poor, and there was not enough space for growing collections. Conditions were so unacceptable that students protested. In 1971, student leaders hired consultants to study the library. In 1972, the legislature provided $3.5 million for a library addition, which opened in 1975. This is an aerial view of the Love North construction site in 1973.

Tom Osborne became head coach of the Cornhusker football team in 1973. Osborne, who was picked by Devaney to be his successor, became one of the most successful coaches in collegiate football. He won 13 conference titles and three national championships before retiring following the 1997 championship season. Osborne then represented Nebraska in Congress from 2001 to 2007 and served as athletic director at Nebraska from 2007 to 2013. He is pictured in the 1980s.

The basement of the agricultural college activities building served as a temporary farm campus union beginning in 1946, and a grand opening was held with entertainment provided by undergraduate Johnny Carson. After over 20 years of lobbying for a new union, $2.5 million was allocated by the regents in 1972. Students objected to building the new union on the green space west of C.Y. Thompson Library, as originally planned. The East Campus union opened in 1974.

In 1981, Martin Massengale was named chancellor. He served through the 1980s before becoming the university system president in 1991. His leadership provided stability after a tumultuous decade. Massengale was hired in 1976 to serve as vice chancellor for agriculture and natural resources. He served as system president until 1994, when he returned to the faculty in agronomy and served as director of the Center for Grassland Studies. In 2017, the Massengale Residential Center was named in his honor.

Ronald Roskens was named president of the University of Nebraska system in 1977 and served until 1989. He had formerly served as chancellor of the University of Nebraska at Omaha from 1972 to 1977. Roskens was president when the Nebraska legislature voted to move Kearney State College into the University of Nebraska system, although the actual transfer did not occur until 1991.

Graham Spanier became chancellor of the University of Nebraska in 1991. Young and progressive, Spanier stressed racial and gender equality and banned smoking from university buildings. He resigned in 1995 to become president of the Pennsylvania State University.

The Nebraska Union was expanded for a second time in 1969. Union Plaza, with Broyhill Fountain, was added shortly after, following the closure of S Street. Great controversy ensued in 1992 when Chancellor Spanier elected to close the nearby parking lot and convert it into a green space for student activities. Here is the original Broyhill Fountain and north parking lot in the early 1990s, prior to its closure.

James Moeser was hired in 1996 to serve as the 18th chancellor of the University of Nebraska. Moeser stressed the importance of student recruitment and encouraged Nebraska's highest achievers to attend the university. A musician, Moeser was noted for coauthoring a school alma mater, "Nebraska! Nebraska!" with Omaha musician Chip Davis of Mannheim Steamroller. Moeser resigned in 2000.

In 1994, five living chancellors gathered during a symposium celebrating the 125th anniversary of the university. Pictured are, from left to right, Joseph Soshnick (1969–1971), Clifford Hardin (1954–1968), Graham Spanier (1991–1995), Roy Young (1976–1980), and Martin Massengale (1981–1991). Massengale also served as president of the university system from 1991 to 1994.

In 2001, Harvey Perlman became the 19th chancellor of the University of Nebraska. During his term, the university experienced an unprecedented building boom, and he successfully led efforts to annex the state fairgrounds for the development of Innovation Campus. Perlman also led the university's transition into the Big 10 conference. In 2016, Perlman resigned as chancellor to return to teaching in the College of Law.

Ronnie Green became the 20th chancellor of the University of Nebraska in May 2016. For the previous six years, Green served as the Harlan vice chancellor for the Institute of Agriculture and Natural Resources at Nebraska. Green received his doctorate from Nebraska in animal science in 1988 and worked in academia and industry before joining the university in 2010.

In 1969, the University of Nebraska Press published *Centennial History of the University of Nebraska, volume 1: Frontier History, 1869–1919*. Its author, Dr. Robert Manley, was a respected author, historian, teacher, folk singer, and Nebraska history enthusiast. Manley died in 2008. R. McLaran Sawyer, a professor of education, wrote the follow-up second volume, *The Modern University, 1920–1969*. Manley is pictured with his guitar during a presentation at the Student Union in 1965.

Elvin Frolik was a graduate, faculty member, extension agent, department chair, and dean of the College of Agriculture. Frolik, along with Ralston Graham, authored *College of Agriculture of the University of Nebraska–Lincoln: The First Century*, published in 1987. Frolik retired in 1975 after 42 years with the university. He died in 1999. He is pictured with test corn in 1945.

Native son Robert Knoll spent 40 years as an English professor at the University of Nebraska, where he was a favorite among students. After his retirement, Knoll authored *Prairie University: A History of the University of Nebraska* in 1995. The Robert E. Knoll Residential Center was named for him after his death in 2009.

This 1946 self-portrait was painted in watercolor by former art professor and museum director Dwight Kirsch. Kirsch depicts himself on a rural road painting an abandoned barn and fields under an expansive prairie sky.

DISCOVER THOUSANDS OF LOCAL HISTORY BOOKS FEATURING MILLIONS OF VINTAGE IMAGES

Arcadia Publishing, the leading local history publisher in the United States, is committed to making history accessible and meaningful through publishing books that celebrate and preserve the heritage of America's people and places.

Find more books like this at
www.arcadiapublishing.com

Search for your hometown history, your old stomping grounds, and even your favorite sports team.

Consistent with our mission to preserve history on a local level, this book was printed in South Carolina on American-made paper and manufactured entirely in the United States. Products carrying the accredited Forest Stewardship Council (FSC) label are printed on 100 percent FSC-certified paper.

MADE IN THE USA